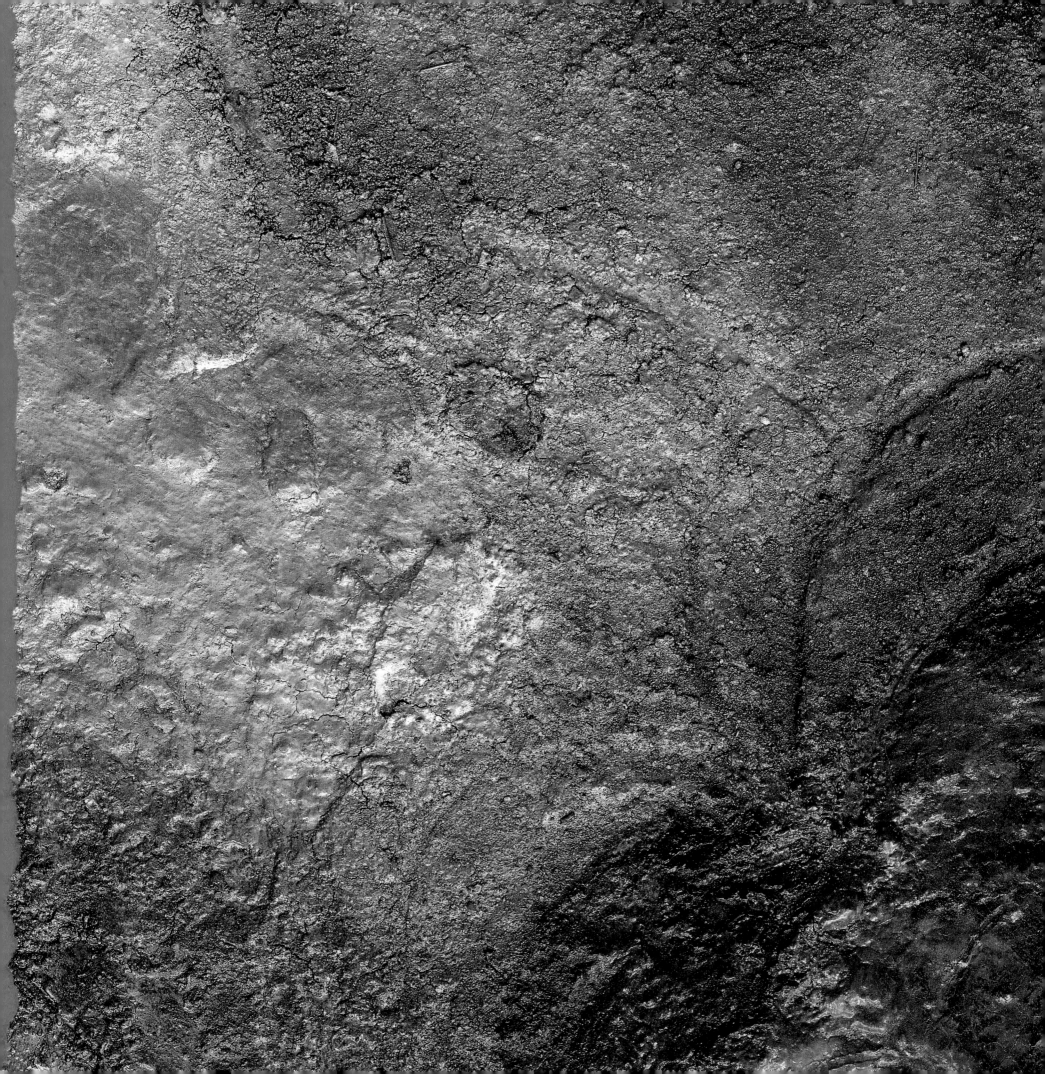

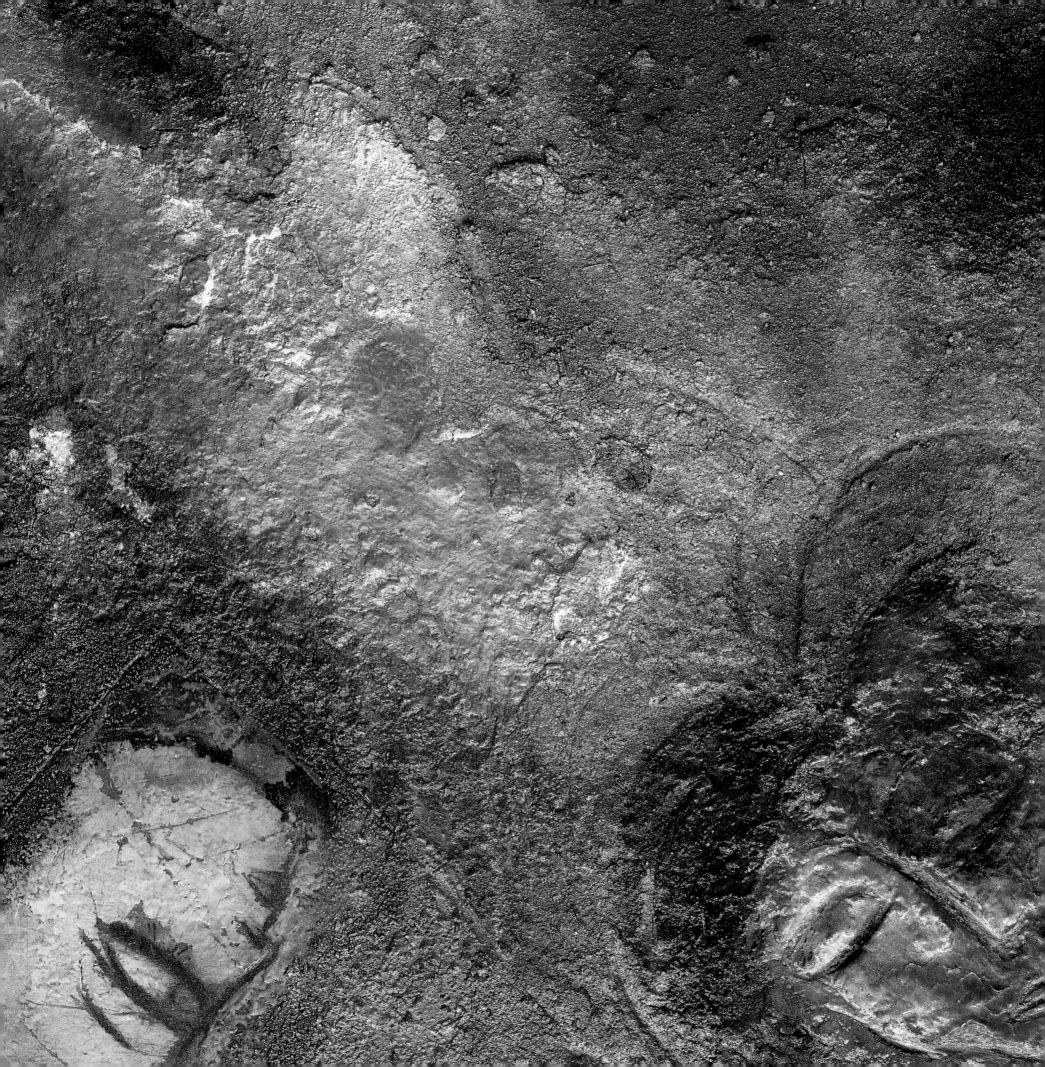

JAMALI

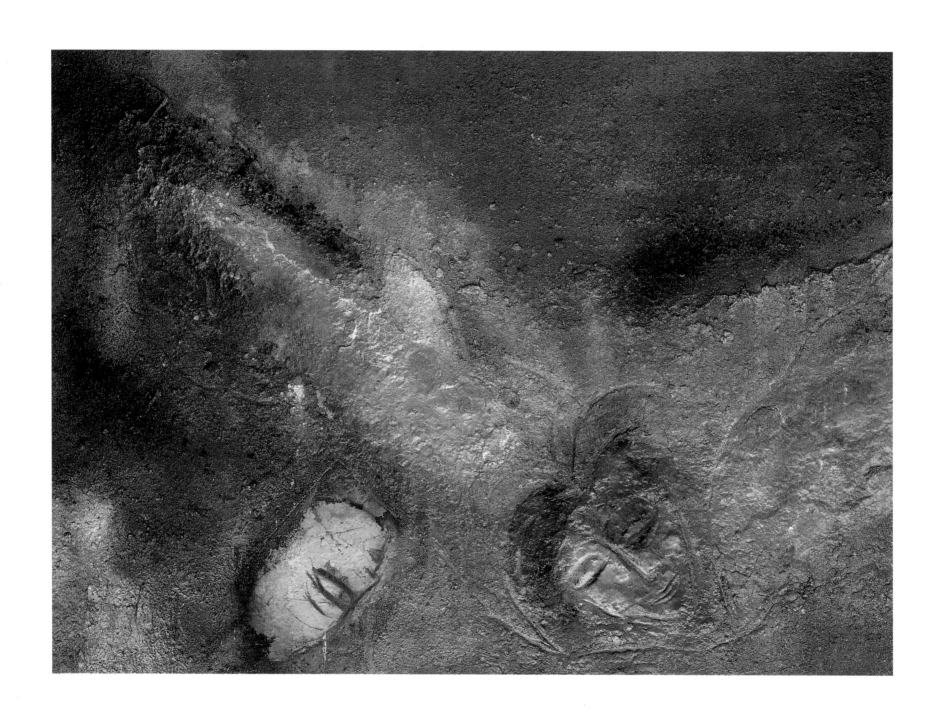

JAMALI

MYSTICAL EXPRESSIONISM

Foreword by Mark Strand

Essay by Donald Kuspit

Rizzoli International Publications, Inc.

IN ASSOCIATION WITH

ART & PEACE, INC.

Library of Congress Cataloging-in-Publication Data

RIZZOLI INTERNATIONAL PUBLICATIONS, INC.
in association with Art & Peace, Inc.

ISBN 0-9656610-0-8

PRINTED IN ITALY

To
A. H. K. Jamali
and
Susan League

Contents

Foreword by Mark Strand · 11

Jamali: Mystical Expressionism
by Donald Kuspit · 15

PLATES

Fresco Tempera 1977–1995 · 33

Oils on Linen 1995–1996 · 123

Industrial Paints on Canvas 1983–1985 · 141

Pigments on Prepared Surface 1976–1994 · 159

Pigmentation on Cork 1993–1996 · 171

Jamali's Surface by Donald Kuspit · 187

Alphabetical List of Plates · 189

Foreword

In Jamali's paintings it is as if the airiest substance had been rendered hard and gemlike, given weight and solidity, made earthbound. One looks at the surface of the paintings, searching it, scanning it for a way in or out, a focal point, a distinguishing mark, but very often there is none. We look until it becomes clear that the surface, the whole of it, has been the object of our gaze. Those luminous sweeps of grit that before our eyes become a cosmos of masterful gestures—always there, yet always emergent—are what compel our attention. We look at his paintings, in which texture and color are collusive as perhaps they are in no one else's work, and imagine that solids are turning to light or vice versa. There are other changes in his work as well: the spread of energy into shapes of rough figuration and back into energy, the force of his paintings oscillating always between the seen and unseen, between containment and release; crusts of light turning into clouds of suggestion, blotches of possibility. In each of Jamali's paintings the blur of existence is lyricized, rapidly recorded in patterns of linear abandon. Each manifests a trust in the notational, in the generative instant, the spark, the vital premise of being. Each is an inducement to reverie. The gorgeous dirt, the glistening scum can be earth or sky—an earth of buried sunsets or a deep calcitic sky—we don't know which. It is all so rich, so fraught with implication, and yet it seems so offhand, so easily done. Those figures that make periodic appearances in Jamali's paintings only add to the mystery. They possess a sexual character that is alternately seductive and reclusive. They seem oddly distracted. They offer their languor to the viewer, but not their attention, which is always elsewhere. I do not know who they are, these spirits or personae, but they lead unpredictable lives in the fix and drift of Jamali's world. Their plasticity is their genius. They seem to float in a delirium of rhythmical suggestion. They are brief formulations of energy, proposals of figuration. They are not final, and yet their existence is inescapable, as much so as the hard color, the buried chroma shimmering like ore just under the surface. They are both made from elements least visible, so that our seeing them constitutes a kind of miracle, one that not only allows us, but urges us to experience astonishment and pleasure at the same time.

Mark Strand

Jamali developed his
dancing/painting/ritual as a
structured discipline which is
strictly observed every morn-
ing in a secluded wooded
area. During this dance/ritual,
pigments are strewn like sand
or earth. The constant pound-
ing of Jamali's feet over
a period of time shapes the
fresco tempera pieces in
rough-hewn archaeological
surfaces. Fresco pieces are
often left exposed to the

elements over long periods of time. Just as it is now theorized that the first art made by humans was the footprint preserved in ancient mud in a dancing ritual pattern, several of Jamali's paintings display the hardened footprints of the artist embedded in the surface as evidence that he was there. When completed, Jamali's paintings are subjected to a series of archival preservatives to ensure their longevity.

JAMALI

Mystical Expressionism

The history of modernist painting is the history of the development of surface, but that development has been seriously misunderstood by the theoreticians who have celebrated it. A good part of my purpose in this essay is to offer an alternative understanding, by way of an interpretation of Jamali's paintings, for they make us conscious of what has been neglected—repressed?—by the more conventional understanding: the unconscious mystical meaning of modernist surface.

It is easy to describe the material changes of surface in modernist painting, for they are readily observable. But it is a mistake to regard such description as understanding—unless what waits to be understood threatens one's expectations. Neglect of the unconscious meaning of modernist surface is less than benign; it indicates fear of its emotional intensity. Conventional theoreticians are in terror of the strong emotion invested in modernist surface by its painter-developers, and do not know how to conceptualize it. And so they refuse to deal with it—blindside it, in deliberate disbelief of the evocative power of modernist surface, indeed, of the emotion it induces in the theoreticians themselves. The disruptive truth of modernist surface—the reason it is a truly revolutionary achievement—is its use of painterly matter as the vehicle for a feeling that has no place in ordinary objective modern life. Jamali's paintings, in their own way, recover the truth of such non-objective feeling, as Kasimir Malevich called it, [*Where Malevich, in his "desperate attempt to free art from the ballast of objectivity," "took refuge in the square form"—the "desert" of geom-*

etry, "where nothing is real except feeling," many other modernists, including Jamali, took refuge in painterly surface, that is, found that feeling was more real in it than in the objective world. Painterly surface seems to make more subjective and expressive sense than geometrical form, for, if "objectivity, in itself, is meaningless" and "feeling is the determining factor," then geometrical form, which remains objectively meaningful, cannot be unequivocally determined by feeling, the way painterly surface, which is as fluid as feeling, can be. Quoted in Herschel B. Chipp, Theories of Modern Art *(Berkeley and London, University of California Press, 1968), pp. 341–42. If, as Alfred North Whitehead argues, the whole point of esthetic experience is to generate a sense of intensity that transmutes experience into something perceptually subtler and emotionally more resonant than it ordinarily is, then painterly surface, which is inherently indefinite and structureless, and as such seems to spill out of and seep through whatever form tries to contain it—to twist free of whatever form tries to "bind" or integrate it—affords a better opportunity for intensity than geometrical form, which has a definite, preordained, irreducibly integral structure.*

To use Kandinsky's language, geometrical form, because it is fixed and axiomatic and crystal clear, is determined by outer necessity, which is why it does not lend itself as readily to inner necessity as painterly surface. Jamali's use of anti-morphic painterly surface is complicated by his Eastern heritage, which functions as a kind of outer necessity—a residue of traditional, even ancient iconography, which he struggles to dissolve in his painterly surface, even as he uses it to signify the extreme or radical states of subjective reality that only the painterly surface can validate experientially. That is, it concretizes the

mystical experience Jamali's Tantric iconography symbolizes. One might say the formal iconography puts us in the frame of mind to receive the emotional wisdom embedded in his painterly surface. The iconography, particular to a certain culture, is the point of departure for the universal mystical experience the enigmatic painterly surface initiates us into.] and thus sidestep what has become the social fate of modernist surface—its domestication as decoration, and, correlatively, its academicization. [*T. W. Adorno,* Aesthetic Theory (*London, Routledge & Kegan Paul, 1984), p. 45 notes that "the non-representational is perfectly compatible with the ideas affluent members of society have about decorating their walls." At the same time, "radically abstract painting," which is what painterly surface at its most intense is, has a certain "power of resistance" to society—decoration—in part because it is "lonely and exposed" (p. 328), in part because of its evocative power, that is, its power to overthrow the objective with the subjective, instantly arouse unexpected, uncontrollable emotions that make no objective sense—that do not seem appropriate in any social situation. Or, to put this another way, the intensity of painterly surface can break through our repression barrier and defenses before we can do anything about it, exposing us to our innermost feelings, which seem impossible to master. They are hardly the existential ornaments we like to think we can wear like jewelry.*

Intense painterly surface creates the panic—one might say the feeling of insanity—that undermines our sense of ourselves as sane, objective beings, and as such is propaedeutic to self-discovery, that is, opens the path to intuition of our truest self, intuition being a mode of intimacy. It is as though, within what Wilhelm Reich calls our character armor—the wall we build not only against the world but our innermost, deepest self—there is, unknown even to ourselves, a secret door that opens onto a passage to that self. Intense painterly surface, if we are attuned to and able to tolerate its intensity, discovers and violently breaks the door open, despite our unconscious resistance. One might call this its emotional "open sesame" or breakthrough effect, which, no doubt, we resist with all our ego strength, for it overthrows what Phyllis Greenacre calls our social self—with which we mistakenly identify our whole ego—forcing us to face the creative self, as she calls it, that we have neglected, and so which appears threatening and alien.

In a sense, in being put to decorative use, as it inevitably is, radical painterly surface articulates the contradiction—tension—between our social and creative selves, or, as Winnicott calls them, our false and true selves. Our false social self is always trying to neutralize our true creative self, just as we try to neutralize radical painterly surface by socializing—falsifying—it as decoration. But if it is truly radical, it is always strangely out of place—its intensity is inevitably at odds with the decorative environment it is supposed to fit into and become a part of—and as such a potential catalyst for an enigmatic experience of enigmatic emotion.] Of course, there is also hatred of unconscious meaning, as Donald Winnicott said, not to say of unconscious feeling—disdain for it that masks fear of it. All the more so in the case of modernist surface: for while it seems entirely material, it is, at its most authentic, profoundly spiritual in import, and as such a paradox. Modernist painting is desperately mystical or "transcendental" in intention, that is, it is a way of withdrawing to the depths of the psyche in rebellion against the emotionally disappointing modern world. Ironically, it uses the modern world's tendency to objectify all subjective experience—to materialize all emotions, or find a physical basis for them—against it: in modernist painting, objective surface resonates with the emotional depth that makes the individual feel truly alive and real—a spontaneous body—in a way that is impossible in the hyper-objective modern world.

Modernist surface is not as reductive—naively materialistic—as it looks to its theorists, but rather spiritually seductive, however subliminally. Indeed, it is a kind of subterfuge—a "dialectical sublimation" [*The term is Gaston Bachelard's. See* The Psychoanalysis of Fire (*Boston, Beacon, 1964; 1938), p. 100. For Bachelard, dialectical sublimation is not the "unconscious repression" psychoanalysts talk about but the "conscious repression" that is a deliberate part of spiritual practice. That is, dialectical sublimation does not relegate sexual—more generally instinctive—energy, to the unconscious, masterfully defending against it (sublimation is one of the mature defenses), but rather consciously—systematically—uses it as a fuel or propellant to reach a "higher plane*

of existence," which in psychic practice means to become ecstatically aware of one's own being, and through it of being as such. Such intuitive consciousness of being seems as irreducible as it is. That is, dialectical sublimation affords a consummate experience of being, and is itself experienced as a consummate state of being. The important point is that instinctive energy, in all its power, is openly acknowledged in dialectical sublimation, rather than repressed into unconsciousness. Tantrism involves dialectical sublimation, and Jamali's Tantric paintings are the product of Tantric sublimation of instinctive energy to achieve a so-called higher consciousness of being.

If, as D. W. Winnicott, Home Is Where We Start From *(London, Penguin, 1990), p. 172 says, "poetic truth…reaches to a whole truth in a flash," then dialectical sublimation is a mode of poetic truth, in that it reaches to the whole truth of being in an epiphanic, ecstatic flash. That is, it is a way of achieving an intuition of sheer givenness, and with that the poet's intuition of his own sheer givenness, and the sheer givenness of poetry. Intense painterly surface instantly conveys such comprehensive poetic truth, suggesting that painting, practiced for its own poetic sake—unencumbered by any worldly purpose, that is, not impinged upon by outer necessity (as verbal poetry cannot help but be, however much it attempts not to be)—is the artistic mode most conducive to an intuitive flash of universal givenness—a momentary sense of the seamlessness of being. Paul Gauguin seemed to believe as much when he privileged painting above all the other arts by reason of its "all-at-onceness" and "musical surface," extravagantly material and thus extravagantly evocative.]* of spirituality in an unspiritual world. That is, modernist surface is a necessarily defensive, deceptive, silent way of communicating spirituality in a secular modern society in which traditional spiritual iconography is no longer viable, and even seems bankrupt when not quaint.

For Clement Greenberg, Cézanne's "mosaic of brushstrokes" calls more attention to the "flatness" of "the physical picture plane" than "the rougher dabs or 'commas' of Monet, Pissarro, and Sisley," [*Clement Greenberg,* Art and Culture *(Boston,*

Beacon, 1965; 1961), p. 52.] and in turn prepares the way for "the all-over, 'decentralized,' 'polyphonic' picture that relies on a surface knit together of identical or closely similar elements which repeat themselves without marked variation from one edge of the picture to the other." [*Ibid., p. 155.)* This kind of picture, which "dispenses…with beginning, middle, end," is the grand climax of what began with Manet's pictures; for Greenberg the rawness—unadorned everydayness—of their subject matter is less revolutionary than the rawness—unadorned materiality—of their surface. Manet's pictures were the first in which "the surface manages somehow to breathe." [*Ibid., p. 125.)* That is, it was a "fresher, more open, more immediate surface" than that of traditional pictures. [*Ibid., p. 124.*] Manet eliminated their "insulating finish"; his pictures were not "'packaged,' wrapped up and sealed in," and as such seemed to possess a "new spontaneity and directness." Repudiating "received notions of unity and finish," they "manhandled into art what seemed until then too intractable, too raw and accidental, to be brought within the scope of aesthetic purpose." [*Ibid., p. 125.*] For Greenberg, this development is simply a matter of the "extension of the possibilities of the medium." He does acknowledge the "plenitude of presence" that results from it, and the sense of "exaltation" such plenitude brings with it, but he thinks that results from the "challenge (to) sensibility" the extension poses.

For Greenberg, the rebellion against finish is entirely an artistic matter—a kind of inhouse overthrow of one order of artistic necessity by another—but for Georges Bataille, the "imponderable plenitude" that results, as he calls the sense of plenitude of presence, involves "reject(ing) the pompous rhetoric that seems to give sense to everyday life, but which actually falsifies our feelings and commits them to a ludicrous abjection." [*Georges Bataille,* Manet *(New York, Skira/Rizzoli, 1983), p.34.*] But, in a kind of circular act of self-justification, the feeling that is most at stake in painting's movement "toward autonomy," in "painting for its own sake," painting that is "a song for the eyes of interwoven forms and colors," is the feel-

ing of rebellion against the "vast didactic structure" of authority, the "mere grandiloquence" that art has become "to dazzle the masses" in order to maintain "the powers-that-be."[*Ibid., p. 35*] For Bataille, traditional art kept the masses at bay and obedient; modernist art suggests—encourages—their liberation through its own liberation of surface. It is a kind of declaration of independence, a form of dissent, useless in socially revolutionary practice but significant as a symbol of personal revolution. For Bataille, it only has power so long as it is opposed to the powers-that-be—positioned in a contradiction. The moment it seems to own itself, that is, to be literally nothing but painting for its own pure sake (as it is for Greenberg)—a kind of visual song, complex in itself, but otherwise pointless in its poetry—it is no longer convincing. There is less to Bataille's autonomy of painting than meets the eye.

My point is that neither Greenberg nor Bataille accept the full implications of painting for its own sake—the creation of a painting that is nothing but an intense surface. Surface is the most subtle, indispensable part of a painting. It is unreadable but felt. The feelings it arouses are at issue; its evocative power is what counts. A painting that has become all surface—that does not pretend to represent the world, and that in fact repudiates and withdraws from it (which is the real import of the refusal to be packaged in a socially pleasing way, and of the revolt against social authority)—has the possibility of telling us more about our deepest feelings, telling us more about ourselves, than a painting that mimes the world, that looks to the world for its substance. The eyes have already proven their worldly worth as the major medium of sexual excitement and ideas, as Freud said; [*Sigmund Freud, "Three Essays on the Theory of Sexuality" (1901;1905)*, Standard Edition of the Collected Works (*London, Hograth Press and the Institute of Psycho-Analysis, 1957*), vol. 7, p. 156.] and appealed to by a purely visual song of interwoven forms and colors, and as such unworldly, even seemingly otherworldly—by an abstract lyric painting that has nothing to say about the world, and thus becomes radically silent, or what Winnicott calls a "cul-de-sac

communication" [*D. W. Winnicott, "Communicating and Not Communicating Leading to a Study of Certain Opposites,"* The Maturational Processes and The Facilitating Environment (*New York, International Universities Press, 1965*), pp. 183–84.]— they can become a medium of something more important, more necessary to existence, to a feeling of being alive and real: the "incommunicado element" that is "at the centre of each person," and that is "sacred and most worthy of preservation," more particularly, the isolated "secret self," "core self," or "true self," as Winnicott variously calls it, that does not want to be found out by the world. A painting that is a song of interwoven forms and colors can become a means of "communication with (the) subjective objects" that constitute the self and "carry all the sense of the real"—its reality, independently of the shared reality of the world. A painting that is all "abstract" surface is unconsciously experienced as the innermost matrix of the self—a kind of externalization or projection of it—and whatever representations that may be embedded in the surface are experienced as subjective objects—just those subjective objects that, as Winnicott says, the mystic withdraws from the world to communicate with, for the salvation of his self. *[Ibid.]* The surface is in effect a mystic substance—a "darkness and formlessness" that cannot be known in any ordinary sense, which can be intuited— poetically known—when memory and desire are eliminated. [*Wilfred Bion,* Attention and Interpretation (*Northvale, NJ and London, Jason Aronson, 1995), p. 26. For Bion, "religious mystics have approximated most closely to expression of experience of it" (p. 30). Bion also notes that "memories are…fallacious," for it "has the defects of its origin in functions of possessiveness and evacuation…if memory could be dispensed with, desire would likewise disappear and vice versa." It is the ambition to remember what was most desirable and thus life-sustaining, and then to dispense with it as beside the point of being, that characterizes mysticism at its most ideal and thorough-going.*] Jamali paints to make this mystic surface manifest, symbolically and "sensationally," which involves eliminating all signs of memory and desire, that is, the subjective objects

that Winnicott spoke of. The residual figural representations evident in Jamali's surface are such internal representations, and the struggle to eliminate them is ongoing and never unequivocally successful: they always re-appear, ghosts in the slime of the surface, amphibiously moving between consciousness and unconsciousness.

Thus, Jamali's mysticism is double-edged—a very complicated dialectic. Initially, its purpose is to make contact with the subjective objects in the depths of his psyche, and give them a kind of artistic life—invoke and resurrect them, as it were. Intuitively recognized, artistically reconstituted as poetic truths, and intensely experienced—they are in fact the most intense part of his psyche, that is, the area where the intensity of being is concentrated—they become sources of nourishment and strength, enabling him to sustain his sense of self in an alien, indifferent—perhaps above all Western—world. But then he tries to dispense with them and face the nothingness of being unflinchingly, fearlessly. This can only be done by rising above the memories and desires which the subjective objects represent—rising above his own history and experience, his own feelings and being, the Western world as the world of his youth in the Himalayas. To do so completes the mystical project.

To put this another way, the self finds its first purity by withdrawing from the world, which comes to seem irreparably impure in contrast to its new found purity—its repair of itself. But such withdrawal, which is ordinarily understood as the core of mysticism, is only its start—a preparation for a more ultimate, crucial withdrawal: of the self from itself. That is, finding its true, core, sacred self in its subjective objects, it rises above that self, as it were, purifies itself completely by dissolving or eliminating—seeing through and beyond—the intense memories and desires given form by the subjective objects, the self's innermost representations of itself. The self becomes selfless, and as such truly sacred, and is able to intuit the simultaneity—oneness—of being and nothingness. One might say the first mystical act of purification is psycho-

logical-"metaphysical," and is an attempt to preserve and quintessentialize the self. It is a necessity of psychic survival—especially in a spirituallly indifferent, even dead world—and what Tantric Yoga practice achieves. The second mystical act of purification affords final enlightenment, the ultimate goal of Buddhist meditation and practice: total disengagement from inner as well as outer worlds, the achievement of an unperturbed state of desirelessness and memorylessness—the higher mindlessness, as it were—which is the necessary and sufficient condition for the intuition of Maya, that is, the discovery of the poetic truth that all being is illusion, even as it is being. With that intuition, comes release from the great chain of being, the endless metamorphosis of being in an infinity of becomings, that is, freedom from rebirth. Jamali's paintings are tokens of his transcendence—*momento mori* of his mysticism—that is, indications of his Tantric Buddhist ambition to liberate himself from being by being as intensely as possible, and then to liberate himself from the intensity of his own being by becoming selfless and thus enlightened, that is, recognizing that there is no necessity to have a self to be, even though that means being seems nothing.

"All artistic operations were originally rites," Ananda Coomaraswamy reminds us, and "the purpose of the rite…is to sacrifice the old and bring into being a new and more perfect man." [*Ananda K. Coomaraswamy, "A Figure of Speech or a Figure of Thought?",* Selected Papers, *Vol. 1,* Traditional Art and Symbolism (*Princeton, Princeton University Press, 1977) p.20.*] As Coomaraswamy writes, this implies both a universal model or archetype of man, usually conveyed through a myth, and a "primitive" or "mixed" method, that is, one in which there is no attempt to separate physical and spiritual values. Greenberg and Bataille are both "modernist" in that they believe it is possible to do so, while Jamali is "traditionalist" in that, in the words of Coomaraswamy, he believes "it is neither advantageous, nor altogether possible, to separate these values,

making some things sacred and others profane: the highest wisdom must be 'mixed' with practical knowledge, the contemplative life combined with the active."[*Ibid., p. 27*] The new and more perfect human being is able to achieve a judicious balance and union of the opposites, while the old imperfect human being tended toward one extreme or the other.

For Greenberg and Bataille the articulation of surface for its own sake that began with Manet was a necessary attempt to separate the physical and the spiritual, indeed, a deliberate attempt at despiritualization or demystification of art, for spirituality had not only become meaningless and absurd in the secular world, but inauthentic in itself. This is why Greenberg dismissively reduced it to "literature," and Bataille regarded it as an authoritarian ploy of the socially powerful designed to distract the masses, and above all preclude the development of criticality by seducing consciousness. Jamali suggests—not without a certain irony—that they have misread so-called modernist surface: it is less purely physical than it seems, however inadvertent—subliminal—its spirituality. Or, if the work of art does become an entirely physical thing, thus losing its "primitive" soul—which is what Coomaraswamy thought had in emotional fact happened to it in modernity—[*Coomaraswamy, "The Philosophy of Mediaeval and Oriental Art," ibid., p. 54 argues that "this abstract art of ours is nothing but a caricature of primitive art; it is not the technical and universal language of a science [of spirit], but an imitation of [its] external appearances or style....The configurations of cubist art are not informed by universals, but are only another outlet for our insistent self expressionism."*] it turns into a willful act of self-expression, the self in question being, as Coomaraswamy said, "autoerotic, narcissistic, and satanic."[*Ibid., "A Figure of Speech or a Figure of Thought," p. 41*]

Jamali's "impurity"—his sense of the inseparability of the sacred and profane, the ideal and the mundane, and ultimately the spiritual and the sexual, or the divine and the bodily—extends to his iconography. For the traditionalist, "art is essentially iconography, to be distinguished by its *logic* from merely emotional and instinctive expression."[*Ibid., p. 37. Coomaraswamy continues: " It is precisely the precision of 'classical' and 'canonical' art that modern feeling most resents; we demand organic forms adapted to an 'in-feeling' (*Einfühlung*) rather than the measured forms that require 'in-sight' (*Einsehen*)." Jamali's "difference" consists in the fact that he combines modern feeling with classical or canonical—archetypal—Oriental iconography, that is, reconciles the modern goal of having qualitatively unique* Einfühlung *with the traditional goal of having* Einsehen *into the ultimate archetypes of being. In other words, he fuses the modern existentialist and the traditional essentialist approaches to art. Jamali's artistic identity is a compound of modern identification with feeling at its most intense—the longing for an ecstatic feeling of transcendence, which is the alternative to and escape from the modern adulation of fact—and traditional identification with the universal archetype. He is, in this sense, truly "multicultural."*

In the modern mentality there are two sources of basic identity: feeling and fact. Each affords a sense of self-identity, despite the fact that they are at odds. On the one hand, there is the ecstatic urge to transcend fact by integrating all kinds of contradictory feelings, orgiastically experiencing them all at once, which affords the sense—at once a feeling and belief (equally temporary)—of being immortal. Mystical modernist surface at its best embodies such modern transcendence. On the other hand, there is the urge to be oneself—hold one's own—in the world, which necessitates observing it coldly and analytically reducing it to hard facts, no doubt in rebellion against soft, slippery feelings, not observable in any ordinary sense. The ultimate goal is to touch base with one's feelings and with the facts of the world simultaneously, integrating them in a single mentality and identity, rather than wildly oscillating between them. In the traditional mentality, intensely experienced subjectivity and objectivity are both paths toward insightful identification with the archetype, which can be invoked by artful ritual—as Jamali does. It is a kind of consummation and limit of being.] Thus, when Jamali paints a hulking, monstrous *Mother,* 1985 crouching like a beast, he is not portraying some suburban housewife gone mad, nor is he expressing his personal feelings about—fear and loathing

of—woman, but rather representing Kali, the Black Goddess of Tantric myth. According to Sri Ramakrishna,

> The Primordial Power is ever at play. She is creating, preserving, and destroying in play, as it were. This Power is called Kali. Kali is verily Brahman, and Brahman is verily Kali. It is one and the same Reality. When we think of It as inactive, that is to say, not engaged in the acts of creation, preservation, and destruction, then we call It Brahman. But when It engages in these activities, then we call It Kali or Sakti. The Reality is one and the same; the difference is in name and form. [*Quoted in Heinrich Zimmer*, Philosophies of India (*New York, Pantheon, 1951*), *p. 564. On a more mundane level, Kali is also the "Loathly Lady" or "Dragon Woman," waiting to be transformed by marriage into a beautiful goddess. As Coomaraswamy, "On the Loathly Bride," ibid., p. 363 writes, "the heroic motif of the transformation of a hideous and uncanny bride into a beautiful woman…represents a universal mythical pattern, underlying all marriage, and one that is, in fact, the 'mystery' of marriage." She emerges from "the slime of the abyss" (p. 367), and experiences the grace of transformation by becoming the object of love. As Coomaraswamy points out, this is a myth of the creative process. Creativity is female in character, suggesting that Jamali's* Mother *is a projection of his own creative power—the monstrous female in him that is able to transform the raw matter of paint into beautiful spirit. Indeed, Jamali pictures her in the process of giving birth, presumably to art, indeed, a whole cosmos of art.*]

For Jamali, the task of art is to represent this Primordial Power in all its playfulness. This can only be done by identifying with it, that is, discovering and mobilizing the Primordial Power within oneself—the Primordial Power that one's own being represents, that is, gives form to. In other words, Jamali returns to the most "primitive" idea of art, the conception of it that makes it a calling: "to make the primordial truth intelligible…to illustrate the primordial image—

such is the task of art, or it is not art." [*Walter Andrae, quoted in Coomaraswamy, "A Figure of Speech or a Figure of Thought?", p. 36. In this context, Alfred North Whitehead's analysis of the relationship between style and power is worth noting. "Above style," he writes, "there is something, a vague shape like fate above the Greek gods. That something is Power. Style is the fashioning of power, the restraining of power. But, after all, the power …is fundamental." See "The Aims of Education and Other Essays", Alfred North* Whitehead: An Anthology (*New York, Macmillan, 1953), p. 98. For Jamali, the task of art is to make the primordial power implicit in such common human experiences as motherhood and sexuality evident by representing them in an uncanny, seemingly vague way. They have a naturally ordained form and typical social meaning, which blind people to their primordial import, but Jamali's loose handling of them strips them of their fixed form and meaning to reveal their primordiality. That is, he uses raw physicality to make a "metaphysical" statement that overturns conventional understanding of important—life-sustaining—human experiences.*]

Primordial power seems abstract, formless, inexorable, and "inhuman"—like fate—compared to human experience, but, paradoxically, without it human experience would lack emotional resonance, and seem repetitious and deadening, and even hollow, that is, altogether lacking in human value. Thus, for Jamali, the artistic problem is to reach and communicate the "metaphysical" level of fundamentality or primordiality without forfeiting the level and style of common experience, which would result in esthetic chaos and a loss of human meaning. Jamali needs both the unrestrained, resonant, seemingly styleless or chance or undifferentiated or spontaneous or instinctive— "abstract expressionist"—gestures that express primordial power, with apparent directness and immediacy; and, at the same time, the imagery of human experience, as a mediator of primordial power, making it seem intelligible, tolerable, even enjoyable, without denying—indeed, vigorously acknowledging—the panic it arouses. Seemingly unsophisticated gestural expression adds an aura of terror and pleasure to the representation of ordinary human experiences, giving them a kind of emotional texture, and thus making them seem more than predictable, stylized events, and as such a procrustean trap

for feeling, and above all suggests their connection to a power beyond yet subliminally evident in them, at least with a little introspection and provocation.]

Mother is a gigantic painting, eight feet by twelve feet, as is appropriate for an image of the mother of our being. She is an ugly creature, her body fiercely painted in the tragic extremes of black and white, and set within a luminous blood-red landscape, as primordial as she is. She is shown crouching or squatting—an almost grotesque position—in the act of giving birth, her vagina an open slit, the mysterious entrance to a black abyss—cloacal cave—in which some unexpected creature dwells, and from which it will emerge, as gory and ugly as its mother. Birth is a somewhat less than sedate event, and Jamali's striking representation of it is hardly our sophisticated society's preferred image of it, but his image has a long and distinguished pedigree in virtually every traditional, so-called primitive society. In other words, it is a primordial image of a primordial act—the "founding" or archetypal act of being rendered in a "founding" or archetypal image of art. In fact, Jamali's representation of birth seems related to—certainly holds its own alongside—perhaps the most famous archaic representation of the act of birth in all its primitive agony and labor: the sculpture of the Aztec goddess Tlazoltéotl, the "Mother of God," in the act of giving birth to Centéotl, God of Corn. (It is worth noting that this goddess, besides being the "creator" of corn, had the power to pardon sinners, if only once in their lifetime.)

What distinguishes Jamali's image from that of his ancestors is the gestural vehemence—violence—with which it is rendered. Birth is a crude, primitive act—hardly a dainty coming out—rendered with the merciless crudity appropriate to it. This restores our sense of its fundamentality. Jamali has given the automatist gesture of release a new expressive fundamentality and instinctiveness—a new energy, which makes it seem freshly unconscious and an existential discovery—by de-abstracting it, as it were, or re-concretizing it, without regressively putting it to the descriptive, empirical

use it had in early modernism, where it functioned as a sign of freshness and originality of perception (in Delacroix, Manet, and above all the Impressionists). It remains an abstract sensation in its own right, but it also epitomizes the intensity of being as such—autonomous intensity as a "proof" of primordial being and power, in the sense in which the "proof of a pudding" is said to be in its eating. Thus, Jamali's gestural intensity is not simply a sign of primordial being and power, but, as in the best Abstract Expressionism, functions as a direct manifestation of it. Alfred North Whitehead has argued that "the maximum of intensity is…dependent upon massiveness,"[*Alfred North Whitehead,* Adventures of Ideas (*New York, New American Library, 1955), p. 252.*] and the body of Jamali's *Mother* is an overwhelming mass of gestures. At the same time, if the intensity is to be more than traumatically engulfing or nihilistic in effect—convey a sense of emotional complexity and individuality rather than naive or undifferentiated vitality—there has to be a variety of contrasting gestures, that is, a sense of detailed as well as energetic gestures. [*Ibid., p. 259. In* Process and Reality (*New York, Humanities Press, 1955), p. 424, Whitehead notes "the lure of contrast, as a condition for intensity of experience."*] Jamali also offers these, in seemingly infinite variety. If, as I think, the task of art, technically, is to "sensationalize" or concretize symbol and symbolically represent "sensationally" concrete experience, whether emotional or perceptual, that is, of an internal or external object—to inhabit the border between symbolic equation and symbolic representation, as Hanna Segal calls them[*Hanna Segal,* Dream, Fantasy and Art (*London and New York, Tavistock/ Routledge, 1991), p. 35 differentiates between "two kinds of symbol-formation and symbol function. In one, which I have called symbolic equation, and which underlies schizophrenic concrete thinking, the symbol is so equated with the object symbolized that the two are felt to be identical … . in the second case, that of true symbolism or symbolic representation, the symbol represents the object but is not entirely equated with it." The best art gets us to unconsciously identify with an object by rendering a symbolic representation in a sensa-*]

tional way that makes it seem to be—equal to—the object. Or else art floods us with sensations that seem so concrete they force us to distance ourselves from them by giving them symbolic meaning, that is, representing them symbolically. Jamali's Mother *does both: its gestures bring the symbol of mother to psychosomatic life and immediacy, while at the same time making the symbol that mediates and "contains" the sensational gestures so dangerously true to primitive emotional life that we are forced to distance ourselves from it and rethinking its meaning—not simply re-experience the reality it represents. We find haven in a new idea of mother, just as we found haven from the banal reality of a symbol of mother—perhaps the oldest symbolically represented being, as the Willendorf Venus and Cycladic figures suggest—in engrossing sensations of her.*

With reference to Jamali's painting of the mother goddess, it is worth noting that, as George Frankl, Archaeology of the Mind *(London, Open Gate, 1990), p. 101 writes, the Venus of Willendorf was once "covered in red ochre," and is one of many similar works that belong to "a common [Aurignacian] culture of the mother goddess," which show an "astounding similarity of technique." While such female figures lacked a face, and Jamali's figure has one, it is essentially anonymous in its universal agony—the seeming dementia induced by the experience of birth.]—then Jamali's gestural intensity accomplishes that task.*

The mother, of course, is the primordial being in everyone's life, and Jamali's raw gestural presentation of her bespeaks the emotional rawness—"touchiness"—with which she exists in everyone's unconscious. The primordial relationship with the mother, and especially her body, has been much emphasized in psychoanalytic thinking. Melanie Klein's conception of the relationship seems particularly relevant to Jamali's frightening picture of her. It is essentially a paranoid projection, suggesting that Jamali has, however unwittingly, represented what Klein calls the "paranoid-schizoid position." It

deals with ambivalence by splitting and projection and occurs during the first three or four months of life; it is characterized by persecutory fears and anxiety over survival. During this position the good (gratifying) breast

produces a feeling of love when the infant is satisfied. This is projected and experienced as the good breast loving the infant, who then internalizes this sense of being loved as a protection against the death instinct. The infant's oral sadism springing from the death instinct and from the bad (frustrating) breast imagined when the infant is frustrated produces hate. This is experienced as the bad breast hating the infant. This breast is also internalized in order to control it. The basic implication is that the infant can feel supported or attacked from within itself. Furthermore, the hate and love can be reprojected or reintrojected, so that if that hate is reprojected or reintrojected a vicious cycle of an increased sense of persecution from within or without is produced; if love is reprojected and reintrojected, a cycle of increased well-being is begun.[*Richard D. Chessick,* A Dictionary for Psychotherapists: Dynamic Concepts in Psychotherapy (*Northvale, NJ and London, Jason Aronson, 1993), pp. 186–87*]

Mother is remarkable for her gruesome, impersonal look: she is hardly the benign, caring person mothers are proverbially supposed to be. She seems as ready to annihilate as to create—to kill the infant she will give birth to rather than to nourish it. Indeed, she seems to embody the death instinct rather than the life instinct. I am suggesting that the picture expresses the annihilative anxiety fundamental to life, an anxiety that is a compound of instinctive aggressive and realistic fear of death. *Mother* is fundamental to Jamali's oeuvre because it conveys what is crucial to his art: the endless struggle between the life and death instincts—love and hate—and the triumph of death, however much love makes a prominent appearance. *Mother's* breasts are askew: the left one—presumably the hateful bad breast—is recessed and gray (the left is conventionally the side of evil, frustration, danger, death); the right one—presumably the loving good breast—is fulsome and pinkish white (the right is the traditional side of goodness, satisfaction, safety, life). This split in character befits

Jamali's ambivalence toward the sacred mother—a primordial ambivalence—and her own inherent ambiguity, as indicated by the conception of her as simultaneously Kali and Brahman—implicitly the all-powerful phallic woman.[*See my essay "The Modern Fetish,"* Signs of Psyche in Modern and Post-Modern Art (*New York, Cambridge University Press, 1993*), *pp. 149–62 for a study of the appearance of the phallic woman—the child's fantasy of the mother as having both womb and penis, and thus at once comforting and threatening—in modern art.]*

Divine Copulation with Death I and *II,* both 1985, make the point cogently: one is always in an ironically loving relation with death when one engages in sexual intercourse. It is an ambivalent experience, lurid because death-infected, but tender because life–affirming. It is, interestingly, not unlike the infant's experience of the mother in the paranoid-schizoid position; the beloved is endlessly introjected and projected in imagination, in a cycle that changes from hate to love, frustration to satisfaction, anxiety and orgiastic satiation, and back again. Love is a consummate experience because it encompasses the emotional extremes. Thus Jamali's paintings have primordial power because they express, with primordial painterly power—they are orgiastically saturated with paint, one might say—what is emotionally basic to existence. This means that they take a primitive point of view; many modern artists have identified with the child, and have struggled to take what they imagine to be a child's-eye view of the world,[*For example, Wassily Kandinsky,* Concerning the Spiritual in Art (*New York, Dover, 1977*), *p. 17, describes children as "the greatest imaginers of all time." In "On the Question of Form,"* The Blaue Reiter Almanac (*New York, Viking, 1974*), *p. 176, he notes "the enormous unconscious power in the child," expressing itself in the child's art, and observes that "the academy is the surest way of destroying the power of the child." Giorgio de Chirico writes that "to be really immortal a work of art must…come close to the dream state, and also to the mentality of children," which sees the world as though it is dream. Quoted in Marcel Jean, ed.* The Autobiography of Surrealism (*New York, Viking, 1980*), *p. 7.]* but few have entered into the emotionally primitive spirit of the child as Jamali has. That is, few understand that the child is emotionally conflicted about existence and about his or her mother—with whom his or her existence is identified, indeed, who seems to embody existence as such—as well as Jamali. They have idealized the child, whereas Jamali is emotionally realistic about it. Jamali accomplishes more; he seems able to regress beyond the child to the pre-verbal infant—to be as emotionally primordial as an infant—and to experience the moment of birth itself.

I submit that the viewer of *Mother* is in the position of the newborn infant, looking up at his or her mother and her loins—they are slightly elevated above the ground on which s/he lays—in agonized awe. The implied infant is not simply in the position we often find the newborn infant in sacred art, namely, resting on the ground to be adored, as in the pictures of the Adoration of the Magi or the Shepherds inspired by St. Brigid's vision of the birth of the Christ child, but fresh out of the womb, traumatized by the experience of birth, and looking back at the bloody abyss and monstrous being from which s/he emerged. Jamali's implied infant is as covered with blood and mire as his or her emotionally magnified and literally gigantic mother. "Love has pitched his mansion in the place of excrement," as William Butler Yeats has Crazy Jane say,[*William Butler Yeats, "Crazy Jane Talks with the Bishop,"* The Collected Poems of W. B. Yeats (*New York, MacMillian, 1951*), *p. 255*] and Jamali has shown us the maternal mansion and excrement of love—implicitly, the infant itself. Clearly, Jamali's lurid mother pre-exists Winnicott's good enough mother, an environment facilitating the infant's development into a healthy child and human being.

Jamali's iconography is consistently archetypal and universal, even when, in a few rare instances, it seems to refer to everyday scenes. Thus, the bodies viewed through the *New York Window I* and *II,* 1985 and 1986, are as elemental as *Torso I* and

II, 1993 and 1989. Similarly, the transfigured face that appears in numerous works— *The Poet,* 1986, *Ragamala in Rajasthan I and II,* both 1988, *The Druid,* 1989, *Morning Ragamala,* 1977, *Age of Science,* 1995, *The Pointing Finger,* 1976, *Stone Face,* 1995, *Bubble Room,* 1995, *Ashes I* and *II,* both 1989, *Meditation III,* 1995, and *Past Present Future,* 1995—has the bold, fixed, generic, schematized features of the archetype. The figures in *Sufi-gee I,* 1990, *Butterfly of Kathmandu ,* 1991, *Bronze Age,* 1988, *Meditation,* 1989, *Figure and Mask,* 1989, and *The Swimmer,* 1990 belong to the same family. *Ishtar,* 1987, *Phoenix,* 1994, *Earthman,* 1988, *Torso III,* 1993 belong to another family of universal figures. The former group is defined by a linear contour overlaid on the "body" of a fluid ground, while the latter seems inherently indefinite, amorphous, and uncontainable—a body that has generalized into a charged atmosphere. In short, Jamali uses a basic, recurrent—indeed, obsessively repeated—typology of figures and surfaces or grounds, which he combines in a variety of seemingly experimental ways. Sometimes figures are paired, sometimes they stand alone. Many have wings, like angels and butterflies. Sometimes they are set in an infinitely deep space, at other times they are inscribed on the picture-plane, as though confronting us—indeed, as though they were our own hallucinations. Sometimes they seem part of a narrative, at other times they seem to exist in and for themselves, their life-stories exhausted. The iconographic as well as formal possibilities are infinite, and Jamali seems to have ventured down the path of each one. But the final imagistic result always remains universal and dream-like—a vision that seems to have arisen from the collective unconscious, even as it is particular to Jamali's unconscious.

Schrödinger's Cat, 1995 is a basic statement of Jamali's method and thinking. It cannot be understood apart from Schrödinger's equation, "the fundamental equation of the science of submicroscopic phenomena known as quantum mechanics, (which) has the same central importance to quantum mechanics as Newton's laws of motion have for the large-scale phenomena of classical mechanics. Essentially a wave equation, the Schrödinger equation describes the form of the probability waves (or wave functions) that govern the motion of small particles, and it specifies how these waves are altered by external influences." ["*Schrödinger's equation*" and "*Schrödinger, Erwin,*" The New Encyclopaedia Britannica, *15 edition, vol. 10, p. 538.*] The equation, for which Schrödinger received the 1933 Nobel Prize in Physics, was a major scientific—and some, including Jamali, would say mystical—revolution, for it replaced "the definite and readily visualized sequence of physical events of the planetary orbits of Newton…by the more abstract (and less readily visualized) notion of probability."[*The Cat Paradox originally appeared in Erwin Schrödinger, "Die gegenwärtige Situation in der Quantenmechanik," Die Naturwissenschaften, 23 (1935), reprinted in Erwin Schrödinger, Selections (Vienna, Verlag der Osterreichischen Akademie der Wissenschaften Braunschweig, 1984), where the paradox is presented on page 489. Schrödinger writes: "one can even set up ridiculous cases. A cat is penned up in a steel chamber, along with the following diabolical device (which must be secured against direct interference by the cat): in a Geiger counter there is a tiny bit of radioactive substance, so small, that perhaps in the course of one hour one of the atoms decays, but also, with equal probability, perhaps none; if it happens, the counter tube discharges and through a relay releases a hammer which shatters a small flash of hydrocyanic acid. If one has left this entire system to itself for an hour, one would say the cat still lives if meanwhile no atom has decayed. The first atomic decay would have poisoned it. The phi-function of the entire system would express this by having in it the living and the dead cat (pardon the expression) mixed or smeared out in equal parts." See "The Present Situation in Quantum Mechanics: A Translation of Schrödinger's 'Cat Paradox' Paper, translator John D. Trimmer, in J. A. Wheeler and W. H. Zurek,* Quantum Theory and Measurement (*Princeton, Princeton University Press, 1983). p. 157.*] On one level, Jamali's art is built on the idea of probability, that is, the notion that a physical object is like a wave in that it has a probable but far from definite form, and as such must be represented in a fluid,

seemingly insubstantial manner, if it is to be authentically rendered. It can only be suggested, never definitively presented. Contrary to conventional expectations, probability theory makes it clear that the physical, at its most basic, has no precise form, only a probable configuration, that is, a shape that can never be exactly fixed, however clear and distinct, it sometimes—but never more than momentarily—seems to be. It is incompletely objective, so to speak.

From Jamali's point of view, this makes everything physical peculiarly spiritual, not to say uncanny: the physical object goes in and out of form and is never unequivocally formed or unformed. It is always in an in-between, transitional state of becoming, and as such never stable. It is always in formation, with no predetermined form and identity, which is why its appearance is always unpredictable, although there are limits—set by the speed of the particles that constitute it—to what it can become. Probability builds ambiguity and indeterminacy into being, indicating that it is a process, which means that it will never have a final, determinate form. As such, probability confirms the mystical belief that being, at its most fundamental level, is always in a state of flux. It is informed by the primordial power of Kali, for it is created, preserved, and destroyed all at once. It has to be visualized for the purposes of everyday life, which makes it seem "inactive" or unchanging—a fully determined being in its final form. As such, it is Brahman. But since its form is never more than probable, it is never Brahman for long: Jamali's figures and faces are sometimes Brahmanesque, but more often—as in *Schrödinger's Cat*—Kaliesque.

Schrödinger's Cat is a kind of scientist's joke about the paradox of probability—an ironic acknowledgement of the problems it raises. The outcome of scientific experiments on the subatomic or quantum level cannot be predicted. That is, because of probability one does not know what pattern or form the spinning subatomic particles will take—how the electrons, positrons, etc., experimentally speeded up, will align, forming a wave of new matter. And whatever pattern

they take—whatever matter is formed—necessarily has, by the logic of probability, a very short life, so that it is not easy to detect. Even more basically, there is no guarantee that the experiment, which is designed to convert energy into matter by the mechanism of speed, will work—no certainty that any wave of matter will appear in the sea of energy. One may be left with a chaotic flux of random particles rather than a coherent form of matter. The paradox of Schrödinger's Cat deals with this frustrating situation of uncertainty, unpredictability, tentativeness, and transitoriness. It posits either a live cat or a dead cat in the "box" of the experiment: particles that form a wave of matter or particles that never cohere enough to behave like a wave of matter. Each is equally probable. Of course, the live cat—the successful experiment—will die, disappearing without a trace, for every wave of matter, however well-formed, eventually crashes, destroying itself. It dissolves into an undifferentiated chaos of splashing particles—a formless foam of energy. [*Ibid*]

At stake in this clearly primordial experiment is the creation of matter and intelligibility: the experiment is an attempt to create something out of nothing, order out of chaos, matter out of motion. The subatomic experimenter unconsciously plays God. Indeed, without realizing it, s/he becomes Kali, symbol of the primordial process of creation, preservation, and destruction, and as such the ultimate cosmic artist. Translated into the contemporary terms of quantum mechanics, the process involves the scientific creation of matter out of energy, its provisional existence, and its collapse back into the flux of energy. Jamali also plays God, but much more consciously: he deliberately invests himself, through the process of art making, in the primordial process of the cosmos, for he realizes that without such cosmic "contact" it is impossible to be authentic, humanly and artistically. His painterly surface embodies this process in all its lyrical and epic character. Through it he identifies with—worships and emulates—the radically self-contradictory goddess Kali, incorporating in herself the beginning, middle, and end—the

entire cycle—of being. From Kali's cosmic point of view, indifferent to human concerns, each stage of being is equally valid. Every one of Jamali's paintings is a Kaliesque experiment in creation at the mercy of primordial probability. That is, the result is sometimes probable, sometimes improbable, and sometimes both at once. And it will never last long—which is why Jamali compulsively repeats the experiment, as though to demonstrate that one must continue to be creative despite the inevitable destruction of what one has created. Creativity can never be lost, despite the fact that what one creates never lasts long and self-destructs. If, in despair at the inevitability of destruction—and despair is a normal human response to it—one stops trying to create, forgetting that creation is as inevitable as destruction, one forfeits one's relationship with the larger cosmic, primordial process of which one is a small but not insignificant part, so long as one continues to create—to experiment. No creative experiment is ever in vain, however much it self-aborts, that is, however much organic art disintegrates into inorganic matter, and inorganic matter disintegrates into energy, which always remains full of probability—abstract potentiality. Perhaps the ultimate creative task—artistic and mathematical—is to visualize probability.

Jamali's *Schrödinger's Cat* is a paradigmatic painting, a kind of position paper, which gives it a special place in Jamali's oeuvre: it epitomizes the probabilistic, uncertain, fluid—altogether problematic—situation of creativity, for which the paradox of Schrödinger's Cat is a metaphor. The painting describes, as it were, the probabilistic character of creativity: the recognition that creativity is probability theory in experimental action—that to be creative one must completely give oneself to probability, thus giving up any attempt to control the artistic experiment. Creativity is in effect a willing surrender to probability, which is to be in a state of automatist grace. More or less in the center of *Schrödinger's Cat*—and there is no privileging of the center in a Jamali painting, for the center implies predictability and control, and one never

knows where and when and how (at what speed) a spiritual-physical transformation will occur, that is, there is no way to predict or control or orient oneself to it—is a black, somewhat tentative, primitive form, seemingly self-generating and self-evolving ("self-complicating"), and thus embryo-like form, incisively drawn in the painterly surface, thus containing and separating some of the surface, if covering it over. Near it—virtually impinging on it—are two more coherent forms, also drawn in the quicksilvery surface, but much more static and less evolved (simpler), and above all not blackened, that is, materially dense enough to be distinguished from the surface, like a figure resting on a ground. It is as though the dense, black, dynamic form is the live cat—the wave with a definite pattern, at once organizing and transcending the chaotic surface—and the two other "experimental" forms are dead cats, that is, inherently chaotic for all their coherence. Or at least half dead and half alive. For while they are transparent and lack the substance of the black cat, they are, like it, autonomous, peculiarly life-like configurations, however much their only substance is the chaotic surface in which they are embedded. Indeed, they are curved like fishes, as though they had spawned from the sea of indeterminate substance, if not, like the opaque cat, on the verge of becoming very different from it.

Their ambiguous association with life is not inadvertent. Schrödinger is also famous for his concept of negentropy or negative entropy, which is a probability of life. His assertion that "the organism feeds on negative entropy" is crucial to the concept of a living open system as distinct from a dead and robotic or machine like closed system. [*Quoted in Ludwig Von Bertalanffy*, General System Theory (*New York, George Braziller, 1968), p. 144.*] Ludwig Von Bertalanffy remarks that organisms are "self-differentiated systems that evolve toward higher complexity (decreasing entropy)," and as such, "for thermodynamic reasons, [are] possible only as open systems—e.g., systems importing matter containing free energy to an amount overcompensating the increase in entropy due to

irreversible processes within the system ("import of negative entropy," in Schrödinger's expression)."[*Ibid., pp. 97–98*] Jamali's partially individuated but still very primitive shapes are on the verge of evolving toward higher complexity, but it is not clear—only probable—that they will become organisms. They are organism-like, but not sufficiently differentiated to be true organisms. They are life in the making—matter in the process of extracting enough energy from the sea to become true cells of life. They may even be specious organisms, an irony or joke of nature—inorganic matter simulating the look of life, as though mocking the miracle of life in the making. What Jamali shows us in *Schrödinger's Cat* is the "experimental" moment when they are "importing matter containing free energy"—the probabilistic matter of Jamali's relatively undifferentiated, highly fluid surface. That is, the creative, thermodynamic—"alchemical"—moment of transformation when life—or what seems life—begins, or at least is "envisioned." "Schrödinger's Cat is a new, even more elusive kind of Cheshire Cat: it is always on the verge of fading away into an atmosphere of energy, yet still, intuitively, a material presence. Like Lewis Carroll's Cheshire Cat, Schrödinger's Cat is probably the case, although it may not be.

What Jamali's *Schrödinger's Cat* renders can be understood in terms of Schrödinger's vision of the living organism as a being that has the "astonishing gift of concentrating a 'stream of order' on itself and thus escaping the decay into atomic chaos."[*Quoted in James Gleick,* Chaos, Making A New Science (*New York, Viking, 1987), p. 299*] Or, as James Gleick puts it, "Pattern born amid formlessness: that is biology's basic beauty and its basic mystery. Life sucks order from a sea of disorder."[*Ibid.*] For Schrödinger, physics deals with "periodic crystals," which are "rather plain and dull" compared with living organisms, which are "aperiodic crystals."[*Quoted in Ibid., p. 300.*] Jamali's primitive, fish-like forms—very elementary, deceptively simple patterns, which look like a rudimentary hieroglyph—are aperiodic crystals, mysterious and peculiarly beautiful—because they are charged with the potential of

life—patterns born amid formlessness, and concentrating in themselves a stream of order, that is, they are able to be fluid without losing form. It is highly probable that Jamali's probability waves are fragile organisms, but then again they may be no more than a novel materialization—crystallization—of formlessness. They may be more entropic than negentropic— more dead than alive. They may only be trace materials, not a trace of life. This spontaneous, mystical, uncertain, problematic, readily reversible moment of the birth or differentiation of matter from energy, and above all life from matter, ecstatically envisioned—and it is only in a state of ecstatic, trance-like meditation that it can be envisioned—is Jamali's fundamental "subject matter." *Schrödinger's Cat* is another version of *Mother,* if more abstract and less agonized. Jamali's cats are as exciting and morbid as her flesh.

Nonetheless, however much *Mother* and *Schrödinger's Cat* are sisters under the skin, their skins are radically different. In the former case, it is made of pure paint, which, however raw— Jamali in fact uses industrial paint—remains a typical art material. It is used in a standard way to paint a standard picture. In the latter case, the painting is made of tempera, the basic material of fresco. It is also a conventional art material. But Jamali uses it in an unconventional way: the surface of *Schrödinger's Cat* is frangible as well as dense, corroded as well as encrusted—poignantly lyrical as well as full of epic portents. *Schrödinger's Cat* is a self-contradictory creature, while *Mother* is self-same. The cat is epistemologically primitive, as it were, while mother is ontologically primitive. Moreover, while tempera is historically familiar, it is also historically obsolete, or at least far from modern, certainly compared to industrial paint. Jamali has revived a traditional material meant to last for eternity (tradition thought in terms of eternity). Paint—especially industrial paint—is not only much less durable than tempera, but seems to have obsolescence built into it. Nonetheless, Jamali is once again paradoxical and

unconventional: the tempera of *Schrödinger's Cat* will last forever—it forms a surface as hard and solid as that of a fresco in a Renaissance chapel, indeed, as firm and monumental as the stone wall in a medieval church—but it reifies transience, more particularly, the mutability of all matter. Thus Jamali uses fresco to fix formless transience rather than to suggest enduring form.

In both *Mother* and *Schrödinger's Cat* the raw material of art is applied with great expressionistic brio and cunning, but an evolution has occurred: in the latter, art is no longer a simple matter of image-making, nor even ingeniously abstract, but "metaphysically" complex. That is, the very stuff of art becomes emblematic of the paradoxical character of being: it is informed by non-being—always on the verge of non-being. Non-being is not simply death in glorified—euphemistic—philosophical form, but implies that there is no God-given reason to be. Thus the problematic character of matter in *Schrödinger's Cat* implies the problematic character of being as such, while in *Mother*, being is never brought into question: who would dare question the being of the mother, especially the primordial mother of us all—the Great Goddess? The brilliant inarticulateness of *Schrödinger's Cat* articulates the problem of comprehending the givenness of being. This difficulty is the "place" where science and mysticism meet: the scientific study of matter, pursued to its depths, unexpectedly issues in a mystical awareness of being—which is what Schrödinger's probability theory amounts to from Jamali's mystical point of view. Schrödinger demonstrated, in precise mathematical terms, the same fundamental indeterminateness—"insecurity"—of being that the mystic Jamali intuits through his artistic meditation on matter: the residue of that contemplation is presented for our own intuitive edification in *Schrödinger's Cat*. Hegel, in the Preface to the *Phenomenology of Spirit*, sharply distinguished between religious "edification" and scientific "insight"—"ecstasy" and "the cold march of necessity"[G. W. F. Hegel, *Phenomenology of Spirit*, trans. A. V. Miller (New York, Oxford University Press, 1977), p. 5.]—but

Jamali, in *Schrödinger's Cat*, suggests—as Schrödinger himself came to believe—that they are reconcilable. For both Schrödinger and Jamali "the 'beautiful,' the 'holy,' the 'eternal,' 'religion,' and 'love' " are not simply, as Hegel says, the expression of desire for the Absolute—a kind of "bait" that may or may not catch the Absolute—but the form the Absolute and knowledge of the Absolute—being as such—takes. [*The issue is one that informs scientific discourse. It ought also to inform serious discourse about art. P. A. M. Dirac, who shared the Nobel Prize in Physics with Schrödinger, notes that "the big advance in the quantum theory came in 1925,"* when, rather than *"keeping close to the experimental evidence about spectra…Schrödinger worked from a more mathematical point of view, trying to find a beautiful theory for describing atomic events. He was able to extend De Broglie's ideas and to get a very beautiful equation, known as Schrödinger's wave equation, for describing atomic processes. Schrödinger got this equation by pure thought, looking for some beautiful generalization of De Broglie's ideas, and not by keeping close to the experimental development of the subject." P. A. M. Dirac, "The Evolution of the Physicist's Picture of Nature,"* Scientific American, *208, 5 (May 1963):46–47. Now the point is, as Werner Heisenberg said, that the beauty of such scientific, mathematical theories (equations, generalizations) is the sign of their objectivity or truthfulness, that is, their correspondence with some "genuine feature of nature." As Heisenberg argued, "the simplicity and beauty of the mathematical schemes" are inherent in nature, and are presented to us by nature itself. Werner Heisenberg,* Physics and Beyond, *trans. Arnold G. Pomerans (New York, Harper & Row, 1971), pp. 68–69. Similarly, as Chen Ning Yang writes in "Beauty and Theoretical Physics,"* The Aesthetic Dimension of Science, *1980 Nobel Conference (New York, Philosophical Library, 1982), pp. 32–33, "the beauty of theoretical description" and the "beauty of phenomena" correspond. Dirac, Yang notes (p. 36), "was led to the theory of anti-matter"—a "profound truth, even though contradictory to experiments"—by letting himself be guided instinctively "toward beauty". It was perhaps Henri Poincaré who first argued that "the feeling of mathematical beauty," which bespeaks the truth of nature—confirms, as Dirac said, that*

"God used beautiful mathematics in creating the world"—originated in the "subliminal self," as he called it. Both quoted in Harold Osborne, "Mathematical Beauty and Physical Science," British Journal of Aesthetics, 24, 4 (Autumn 1984):291, 292. While Jamali's art is far from mathematical, he also believes that beauty bespeaks being at its most fundamental, that is, the "creative" flux of being in which matter is constantly converted to and functions as a sign of energy, and vice versa. That is, for him the artistic—as distinct from mathematical—ability to create religious, mystical beauty— whether of surface, space, or figure—that exists simultaneously tangibly and intangibly, is an index of objective truthfulness. Einstein once said that "The most beautiful experience we can have is the mysterious. It is the fundamental emotion which stands at the cradle of true art and true science." Quoted in Osborne, p. 299, n. 14. It is this fundamental emotion—this beautiful experience of the mysterious—that Jamali attempts to create, indicating the truth of his art.]

The primitive *Mother* is a very substantial creature— solidly grounded on primordial being—compared to *Schrödinger's Cat* which exists on the border or interface between being and non-being. The physical and spiritual converge, indeed, seem paradoxically the same—even more paradoxically, interchangeable—on this border. That is, the physical spontaneously becomes metaphysical, and the spiritual spontaneously becomes physical. However unstable the transformation—however much each can and does revert, with equal spontaneity, to its opposite—it is a fact of being: the oscillation between being and non-being is indisputable. *Mother* is, after all, however powerful, just another image of a certain being, but *Schrödinger's Cat* shows the impossibility of imagining being at its ultimate—being when it seems to become non-being. *Mother* is fully visible in all her monstrousness, while *Schrödinger's Cat* approaches invisibility, which, in a strange way, is more monstrous. We are disturbed by Jamali's bloody *Mother,* but we can fix her clearly in our gaze and master her appearance. But there is nothing to grasp when we reach for *Schrödinger's Cat*—nothing that decisively appears—which is even more disturbing. *Mother* signals

Jamali's psychological authenticity, but *Schrödinger's Cat* indicates his mystical authority, for it shows him accepting— indeed, embracing—non-being. More than his Tantric iconography, more even than his Buddhist pursuit of enlightened detachment, it shows his profound understanding of the *mysterium tremendum:* his willingness to submit to the mystery of being, and follow its artistic consequences wherever they may lead.

The feeling of the *mysterium tremendum*—the sense of being "in the presence of that which is a mystery inexpressible beyond and above all creatures," to use Rudolf Otto's famous words, is the core of mystical experience.[*Rudolf Otto, The Idea of the Holy (New York, Oxford University Press, Galaxy Books, 1958), p. 13*] "It has its wild and demonic forms"—Jamali's "crude, barbaric" *Mother* is one—and "can sink to an almost grisly horror and shuddering," as she does. In a sense, the "intoxicated frenzy" of Jamali's overpowering surface, in both the *Mother* and *Schrödinger's Cat,* is a residue of this demon worship, however subtler—more peculiarly inhibited—the surface of the latter. But, as Otto writes, "the most effective means of representing the numinous is 'the sublime'" [*Ibid., p. 65.*] the *mysterium tremendum* at its most pure and inexpressible—and it is in Oriental art that the sublime is particularly evident, in and through "*emptiness* and *empty distance.*"[*Ibid., p. 69.*] Jamali's space, however activated as temporalized surface, is consistently sublime. There is an inner expansiveness to Jamali's space—a tendency to the abysmal indefiniteness of the infinite—which is authentically numinous. In work after work we see Jamali struggling to express the inexpressible—the most paradoxical ambition of art. I am suggesting that in a painting by Jamali the space surrounding the figure—the space in and through which it exists—is as important, indeed, mystically more important, than the figure itself. *Schrödinger's Cat* makes this self-evident, but it is evident as well in virtually every other painting; however secondary the space appears to be to the figure, it is more sublime—has a more numinous, inexpressible presence—than it. The space

is in effect consecrated ground. Indeed, as in *The Event Horizon*, 1995, it poignantly represents the ground, as the collaged dead leaves suggest. The blackness that appears in so many of Jamali's paintings is not only emblematic of the darkness and silence—the negativity—that Otto regards as the two "direct methods" by which Western art represents the numinous, but of the secretly full emptiness beyond the ordinary expression of being.[*Ibid., p. 68.*] "The darkness," writes Otto, "must be enhanced and made all the more perceptible by contrast with some last vestige of brightness, which is, as it were, on the point of extinguishing," indicating that "the 'mystical' effect begins with semi-darkness," but the colorful vestiges of brightness typical in a semi-dark Jamali painting also signal the mysterious fullness latent within the manifest emptiness of the darkness. Similarly, the profound silence of Jamali's figures—each is subliminally emblematic of Jamali himself—is that of the "prophet and psalmist and poet" who "feel the necessity of silence" in "spontaneous reaction to the feeling of the actual *numen praesens,*"[*Ibid., pp. 48–69*] but it is also that numinous actuality at its most inexpressibly sublime, that is, the silence is an index of the inexpressibility of the Absolute in all the mystery of its being

Jamali's numerous figures and faces may seem like simple physical "incidents" on the somewhat more metaphysically complicated, often stormy ground, and may seem to stand to it the same way secondary unconscious process stands to primary conscious process, that is, as a rational, seemingly clarifying overlay on the psychodrama of irrational processes evident in the ground. But the figures, and especially the faces, have their own illogic—their own mysticism. They add a marvelous resonance to the poignancy of the ground. Inscribed on and simultaneously embedded in the ground, they borrow a certain substance from it, even as they remain disembodied spirits: they are at once immanent in and transcend it. They seem to emanate from the ground, sometimes

resting on it as though it was solid ground, at other times sinking into it as though it was quicksand. They have a dream-like quality; they are at once ego fantasies and id-driven. Above all, for Jamali, they are transient human-like manifestations of the divine mystery. Born from the matrix of being which the ground is, they remind us that it is not beyond human reach.

The mystery is accessible to human beings—if they plunge into it and let themselves be transformed by it, that is, mutated into beings that are at once higher and lower than human being—demonic and angelic simultaneously.

Thus the mysterious incoherence and inchoateness of Jamali's bodies and the poignant innocence, however subliminally tragic, of his faces. The bodies seem in perpetual metamorphosis—a perplexing becoming, as though they could never decide their final form. They belong to another order of being, and seemed undecided about what appearance they should take on earth—in what form they should declare their presence to human beings. But they are already a part of human being—allegorical personifications of the divine element in human being. In a sense, Jamali's whole effort is to extract that divinity and make it self-evident—visible, in whatever strange, shaky form. Perhaps most shaky and strange of all is the scrambled, sinuous, irreal body—an eerie mix of line and luminosity—that mysteriously appears, like a spontaneous revelation, in *Sufi-Gee I,* 1990, *Metaphysical Painting,* 1989, *Butterfly of Kathmandu* 1991, *Meditation,* 1989, *Susst,* 1988, *Play* 1993, *Bhaiya-Bhaiya,* 1988, *Metaphysical Bicycle I,* 1990, and *Ashes I,* 1989. These figures, by reason of their often superimposed parts, seem to exist in all dimensions—time—at once, which suggests that they can transcend any particular dimension. However different, all the figures have a strong family resemblance, as do Jamali's many faces: those of *The Poet,* 1986, *Sufi-Gee in the Evening,* 1994, *Ragamala in Rajasthan I and II* both 1988, *The Druid,* 1989, *Journey of Hope II,* 1994, *Morning Ragamala,* 1977, *Age of Science,* 1995, *The Pointing Finger,* 1976, *Stone Face,* 1995, *Bubble Room,* 1995, *Profile* 1988,

Meditation III, 1995, *Ashes II,* 1989, *Past Present Future,* 1995, *Mask,* 1995, *Tantra Monkey,* 1996, and *Tin Man,* 1996. All these faces—many heavily patinaed—seem to have been excavated from the ground on which they appear, just as the figures seem to have descended onto it from some seventh heaven. They all "occur" to Jamali in the course of the ecstatic, shamanistic activity—he literally does a kind of Sufist dance or performance to induce an ecstatic, visionary trance—which painting is to him. Clearly, they are his own "original face," to use Michael Eigen's term—the quintessential manifestation of his primordial being—in its infinite variety of moods. And those ineffably expressive bodies are his own spirit shapes.

Mark Levy uses a beautiful term to describe the kind of artist Jamali is: "technician of ecstasy." Shamans, writes Levy, are "spiritually advanced individuals" who "translate ineffable messages of the sacred into secular language…understood by all." [*Mark Levy,* Shamanism and the Modern Artist: Technicians of Ecstacy, (*Norfolk, CT, Brambel Books, 1993), pp. ix*] The shaman "can access alternating states of consciousness at will," and "recognize the qualities of each state," that is, "become aware of the differences between certain trances" and articulate them. The shaman also "serves [his or her] community and fulfills vital needs."[*Ibid., p. x*] The shaman is compassionate, in a very Buddhistic way: the enlightenment and salvation—the condition of the interior life—of everyone is important for him or her, not only his or her own enlightenment and salvation. Shamanistic practice is social as well as personal—for the greater glory of human life not simply the vanity and edification of the individual. Indeed, the shaman who practices simply for himself or herself is inauthentic: the insights he or she gains in his or her ecstasy must be made available to everyone—must be used to transform the community at large. To use Otto's terms, the shaman is able to experience and assimilate—metabolize into his own being, as it were—the aweful, overpowering, urgent charac-

ter of the *mysterium tremendum,* and turn it to general human advantage. The shaman, then, not only tries to express the inexpressible, but to heal the world's misery in the process of doing so.

Art has become a sanctuary for shamanism in the age of science, although, as *Schrödinger's Cat* suggests, some scientific practice is shamanistic in effect if not in principle, that is, it unwittingly expresses the inexpressible. As Levy writes, the shamanistic artist is a seer, dreamer, and performer, often all at once. That is, the shamanistic artist not only uses his or her art to achieve visionary insight into primordial, sacred being, but to articulate it, often in the form of a dream that can be interpreted—sooner or later understood—by other people. The shamanistic artist must be able to perform his or her insight for the world as well as use performance to arrive at it: the total shamanistic process is a communal as well as mind-altering performance. Thus shamanism is an attempt to raise the spirits and consciousness of a disspirited, unself-aware community by means of the catalyst of the self-conscious shamanistic individual. The shaman is able to alter his or her consciousness to reach a state of mind in which he or she becomes aware of what is primordial in the psyche, and to bring that knowledge back so that it can be used to enlighten and thus liberate the individual psyche. The shaman is able to survive an experience—an emotional and cognitive ordeal—that would destroy many people: contact with the primordial truth of being. Such contact is, in and of itself, enlightening and liberating—it liberates us from the mundane world in which we tend to lose our sense of being—and thus a kind of healing, that is, restoration of being. Jamali's saturated, esoteric paintings—many are literally weighty as well as iconographically exotic—have their necessary place in our secular world: they are among the important mystical efforts to save humankind from itself by restoring its sense of the divine possibilities of being—the possibility of being divine while being all too human.

FRESCO TEMPERA

1977-1995

1. Bhaiya-Bhaiya

53 x 39 in.

(134.6 x 99 cm)

1988

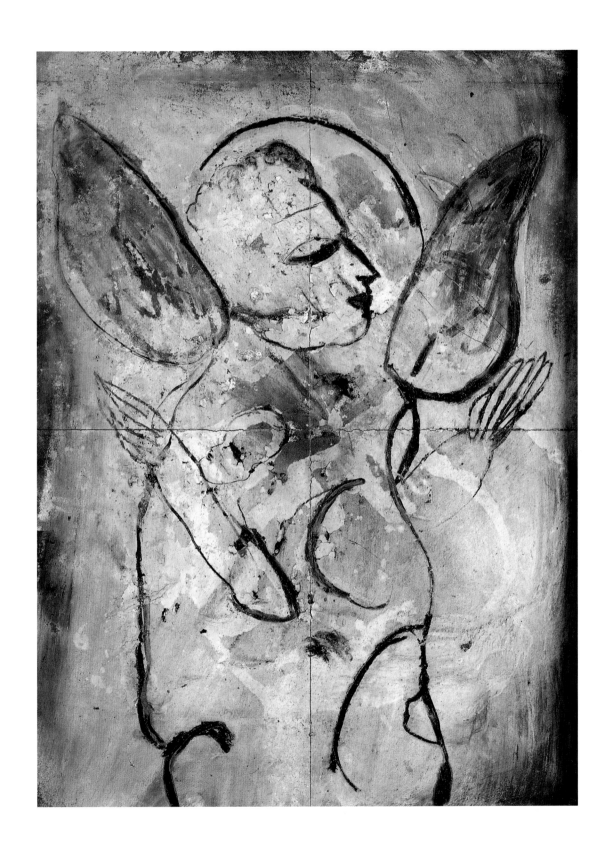

2. Herculanaeum

80 x 60 in.

(203.2 x 152.4 cm)

1985

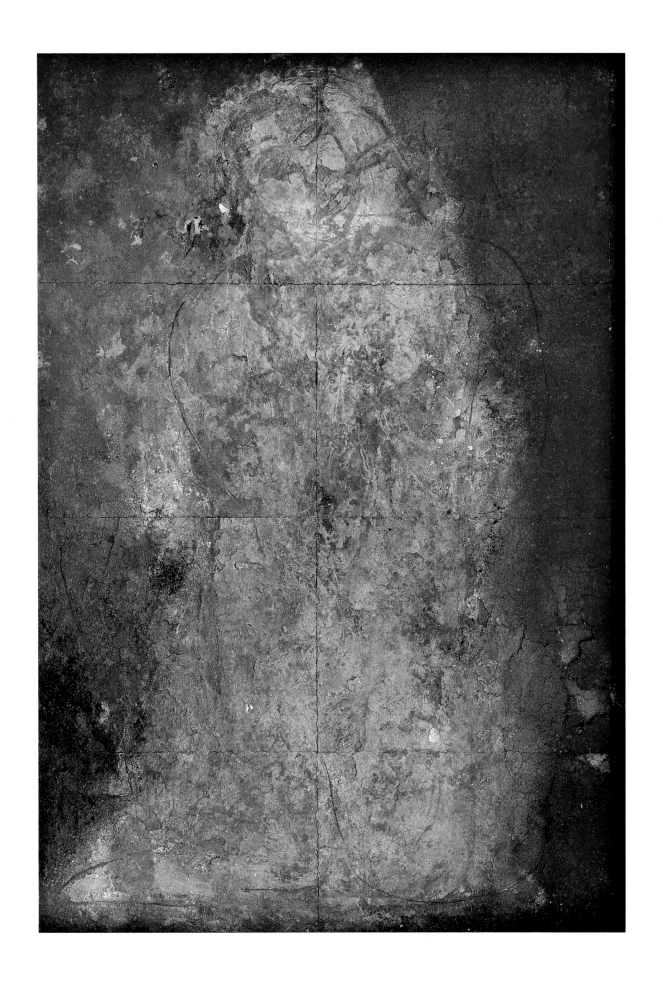

3. The Swimmer

57 x 107 in.

(144.8 x 271.8 cm)

1990

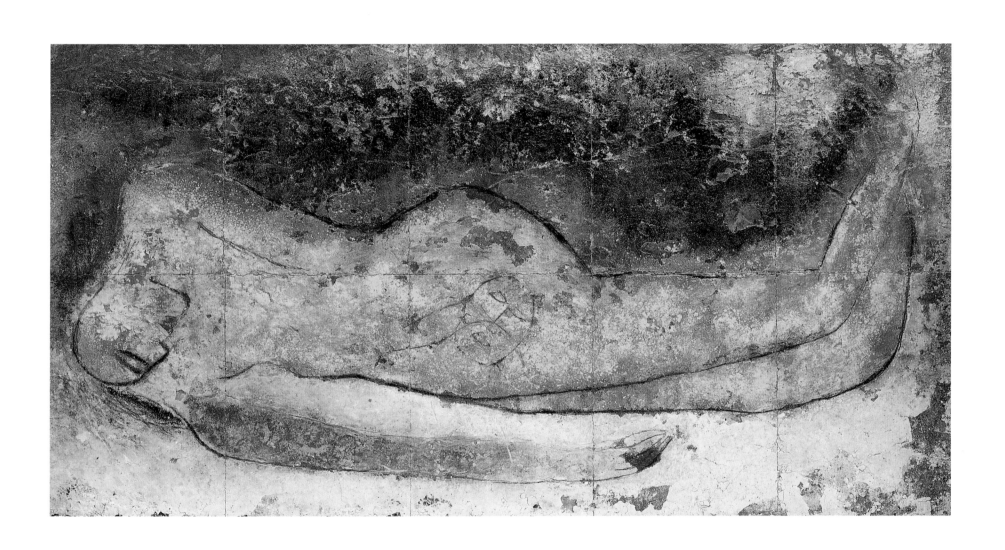

4. Ishtar

105 x 55 in.

(266.7 x 139.7 cm)

1987

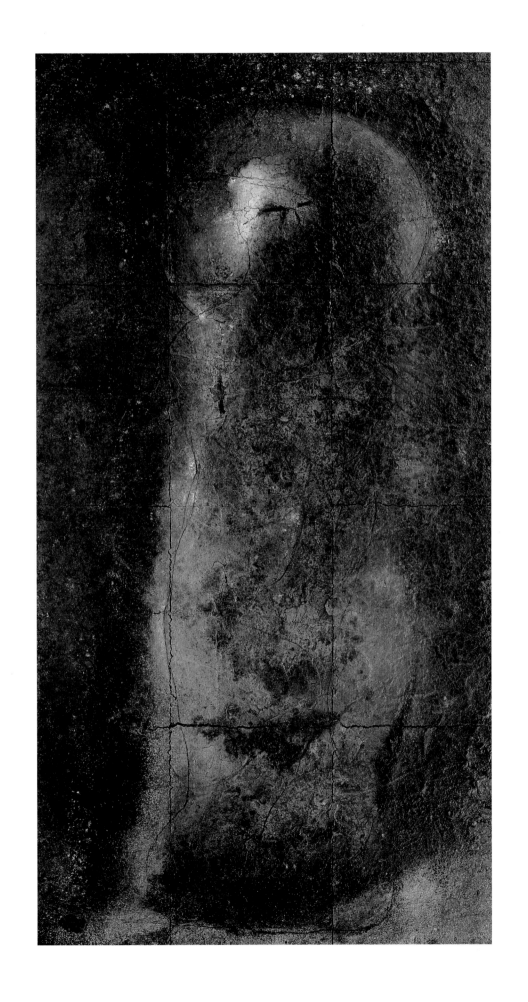

5. Morning Ragamala

26 x 20 in.

(66 x 50.8 cm)

1977

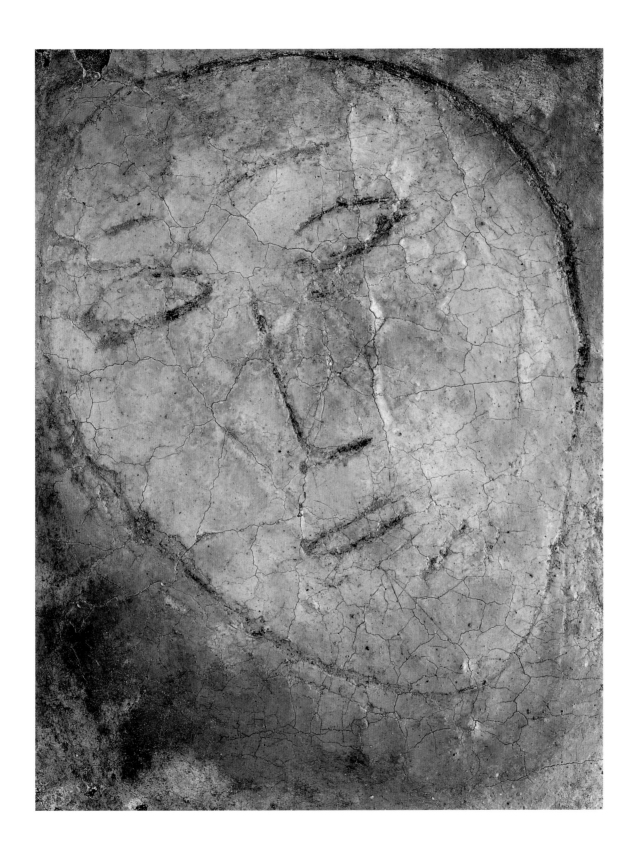

6. Figure and Mask

84 x 60 in.

(213.4 x 152.4 cm)

1989

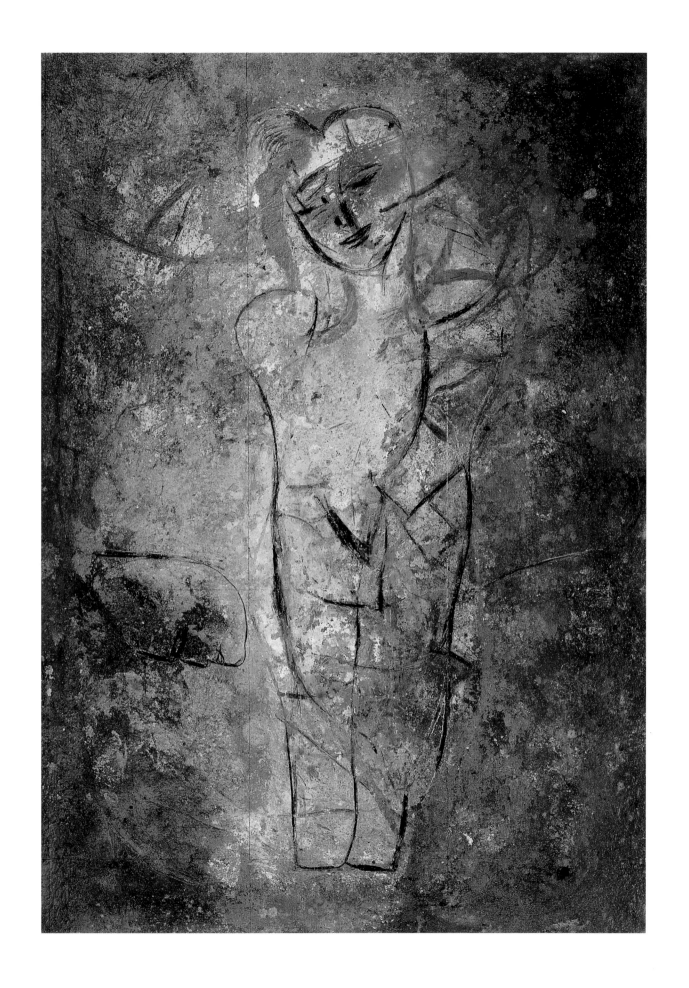

7. Angel Pavon

84 x 60 in.

(213.4 x 152.4 cm)

1987

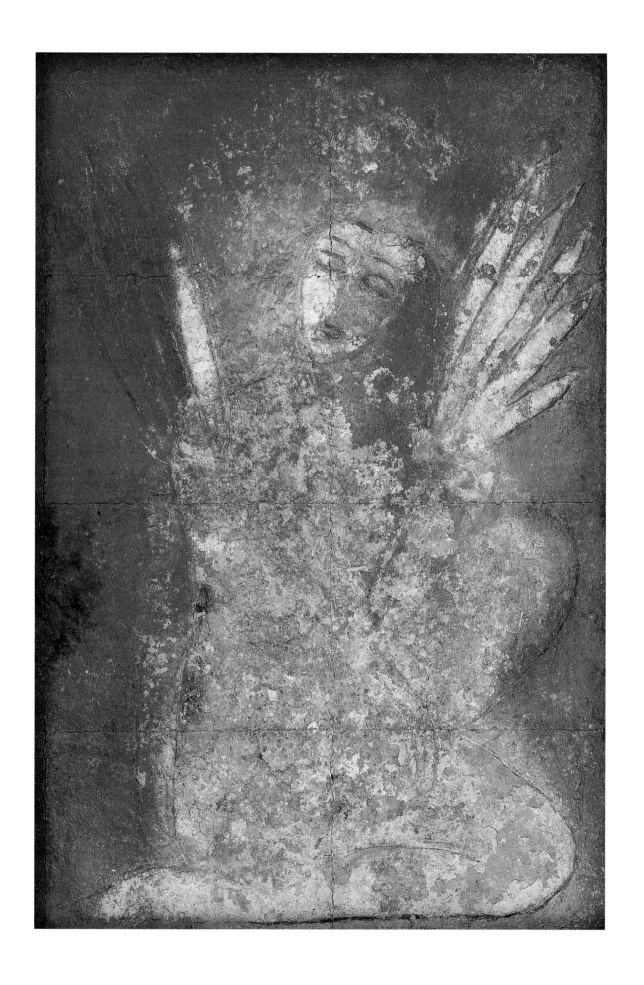

8. Journey of Hope II

60 x 84 in.

(152.4 x 213.4 cm)

1994

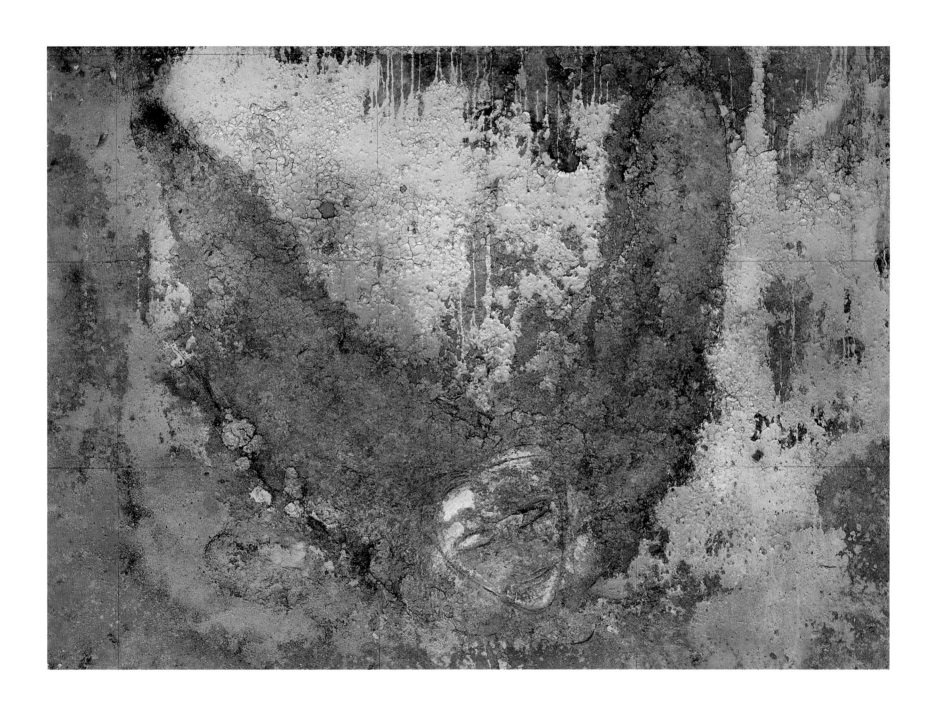

9. Journey of Hope

58 x 110 in.

(147.3 x 279.4 cm)

1993

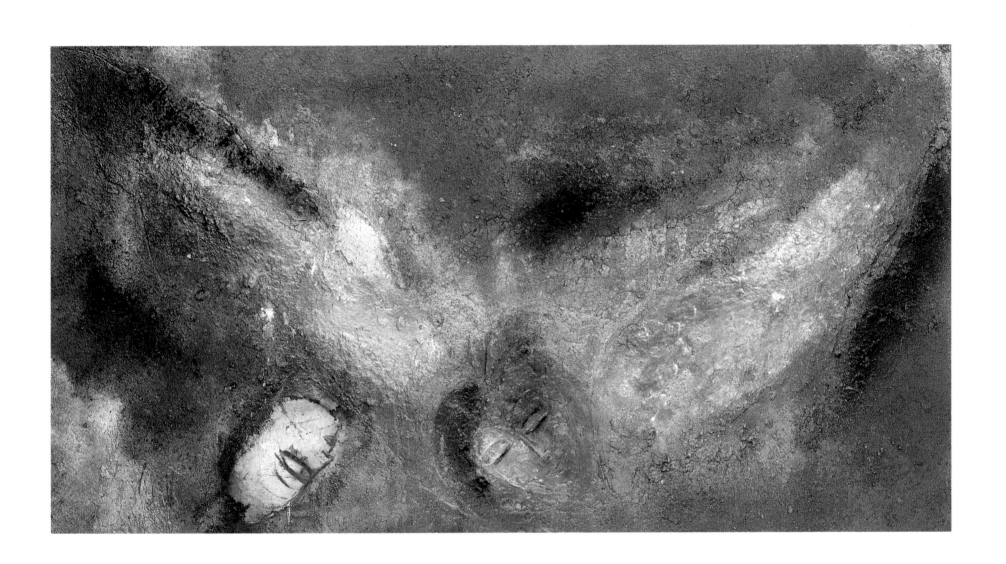

10. Kneeling Figure

75 x 57 in.

(190.5 x 144.8 cm)

1985

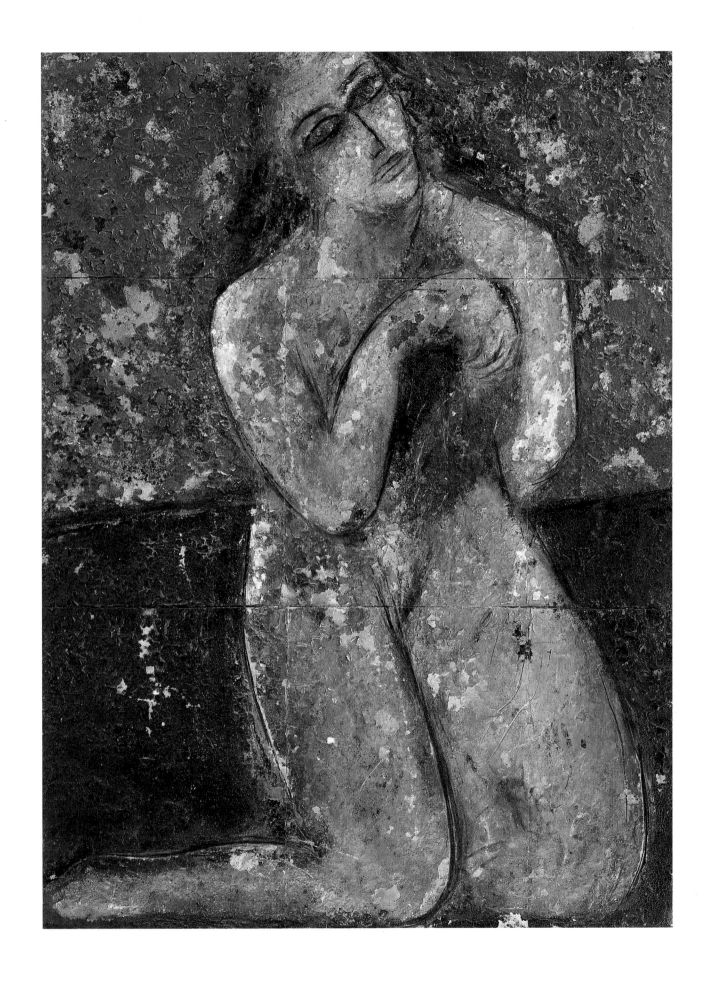

11. The Druid

39 x 53 in.

(99 x 134.6 cm)

1989

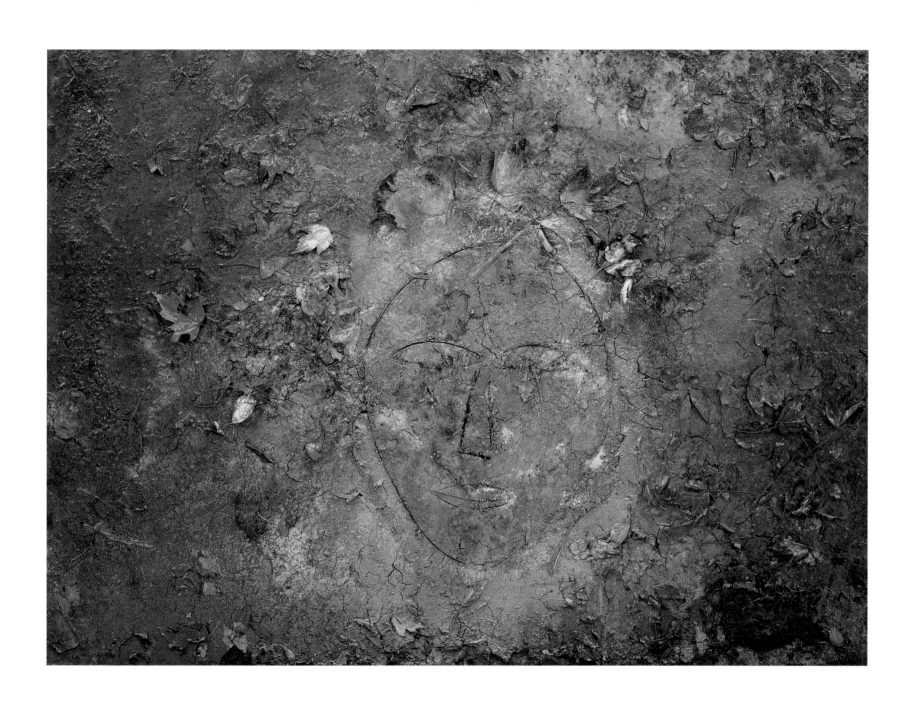

12. Meditation III

53 x 39 in.

(134.6 x 99 cm)

1995

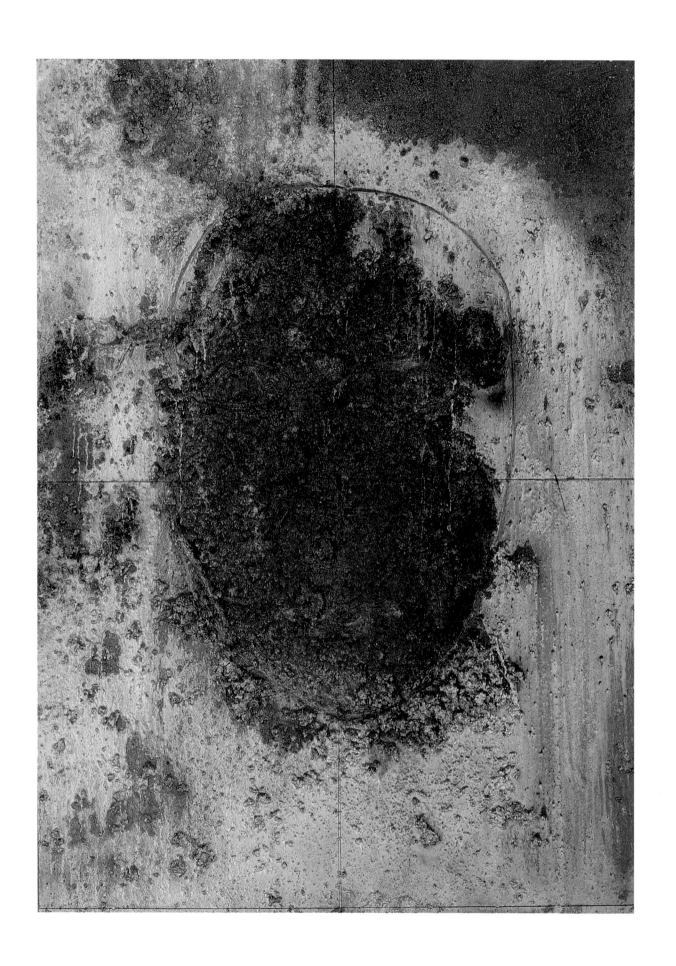

13. Haiya-Haiya

53 x 39 in.
(134.6 x 99 cm)
1988

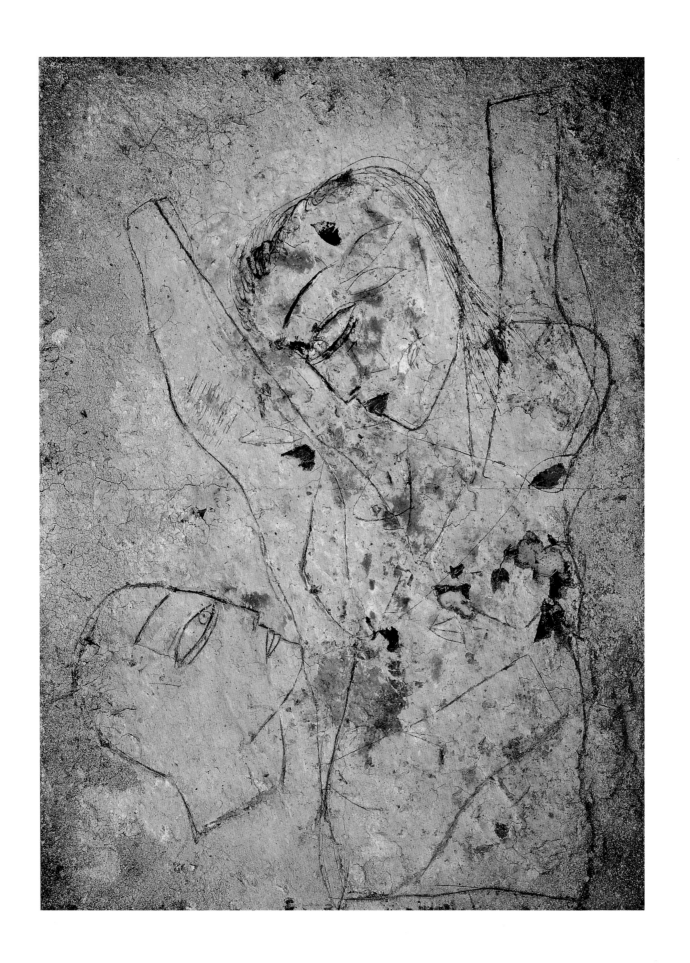

14. Past Present Future

38 x 32 in.

(96.5 x 81.2 cm)

1995

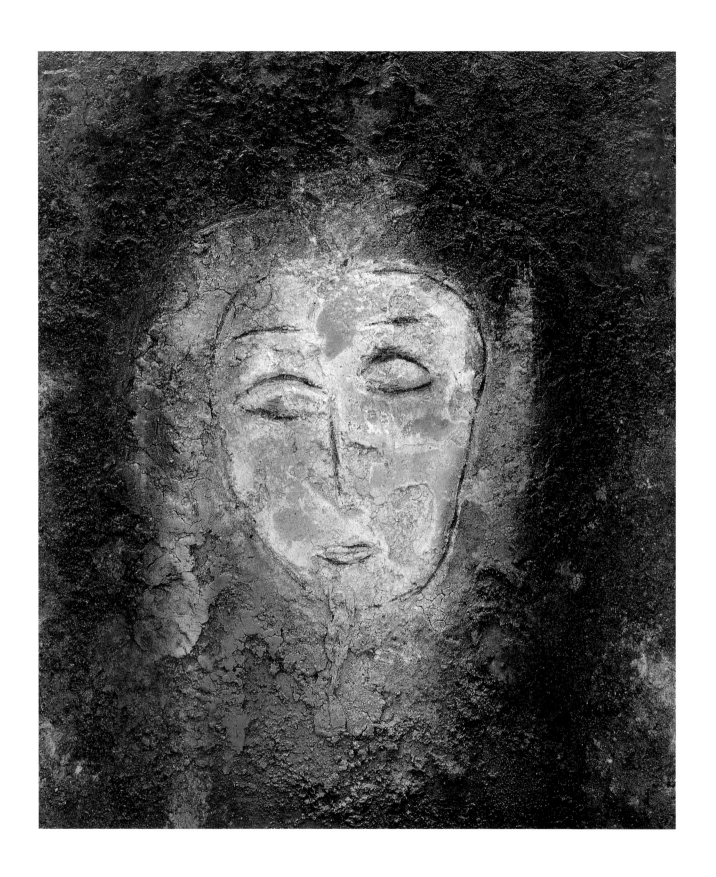

15. Schrödinger's Cat

52 x 38 in.

(132 x 96.5 cm)

1995

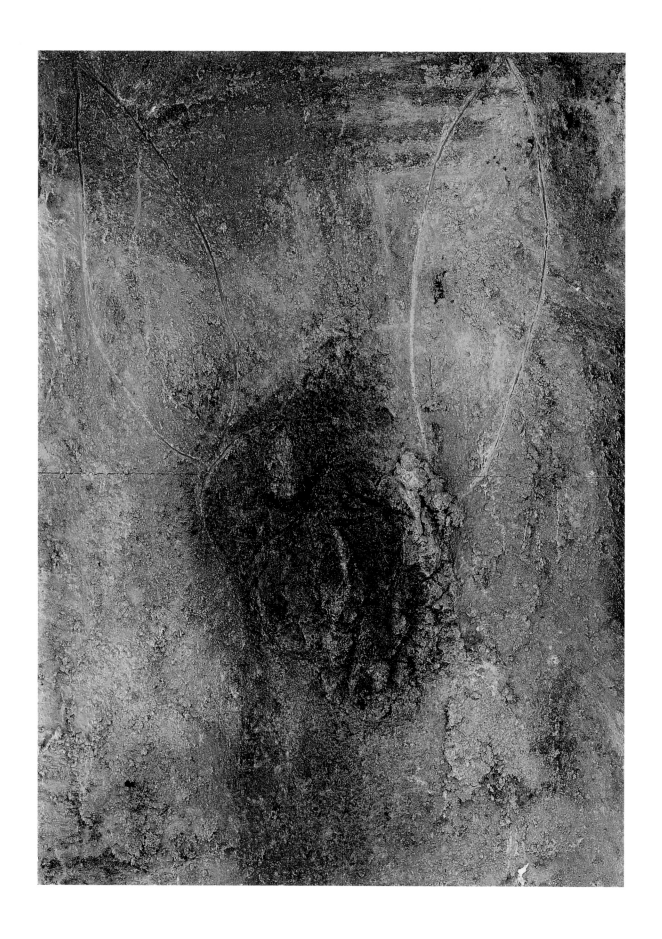

16. Bronze Age

58 x 108 in.

(147.3 x 274.3 cm)

1988

17. Ashes I

27 x 27 in.

(68.6 x 68.6 cm)

1989

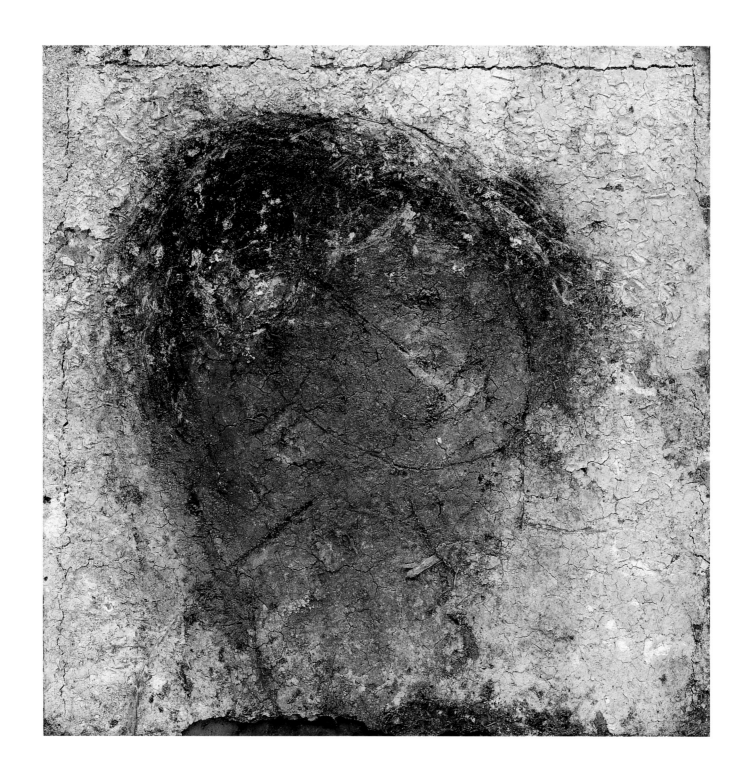

18. Ashes II

34 x 34 in.

(86.4 x 86.4 cm)

1989

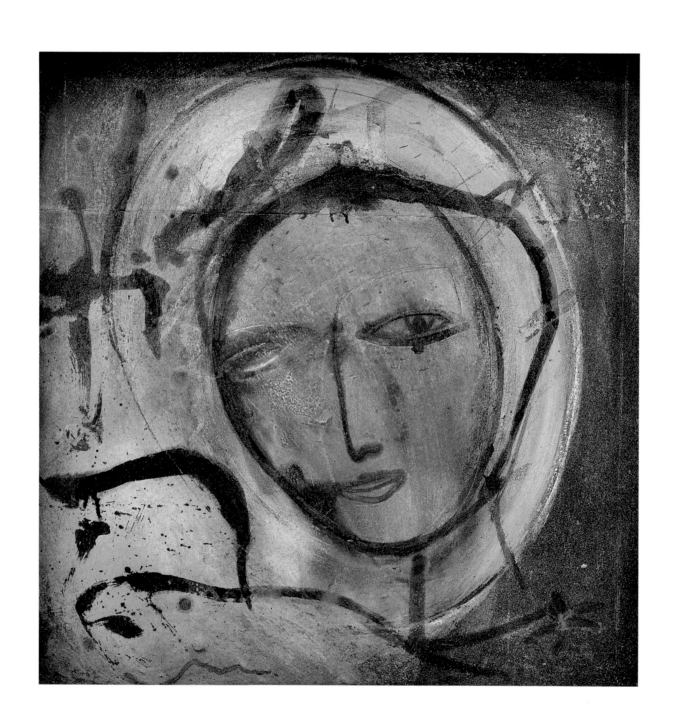

19. Stone Face

38 x 32 in.

(96.5 x 81.2 cm)

1995

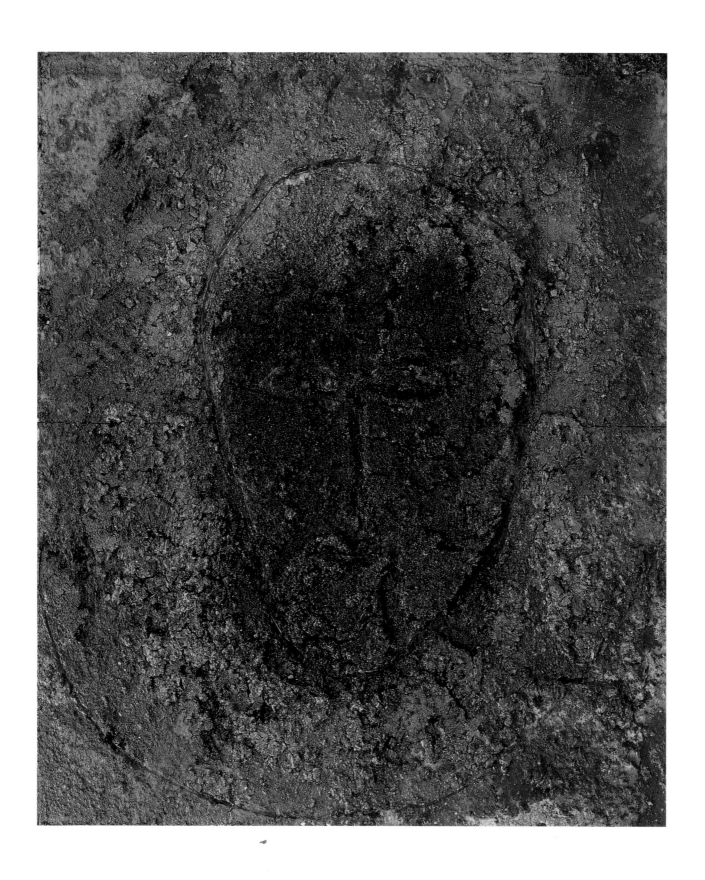

20. The Poet I

26 x 20 in.

(66 x 50.8 cm)

1979

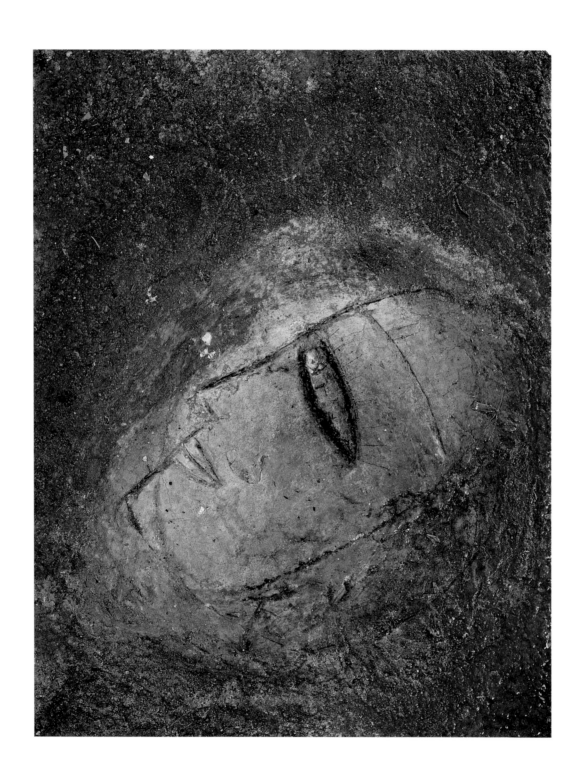

21. Torso III

60 x 84 in.

(152.4 x 213.4 cm)

1993

22. Torso I

58 x 108 in.

(147.3 x 274.3 cm)

1993

23. Torso II

60 x 84 in.

(152.4 x 213.4 cm)

1993

24. Separation

120 x 120 in.

(304.8 x 304.8 cm)

1995

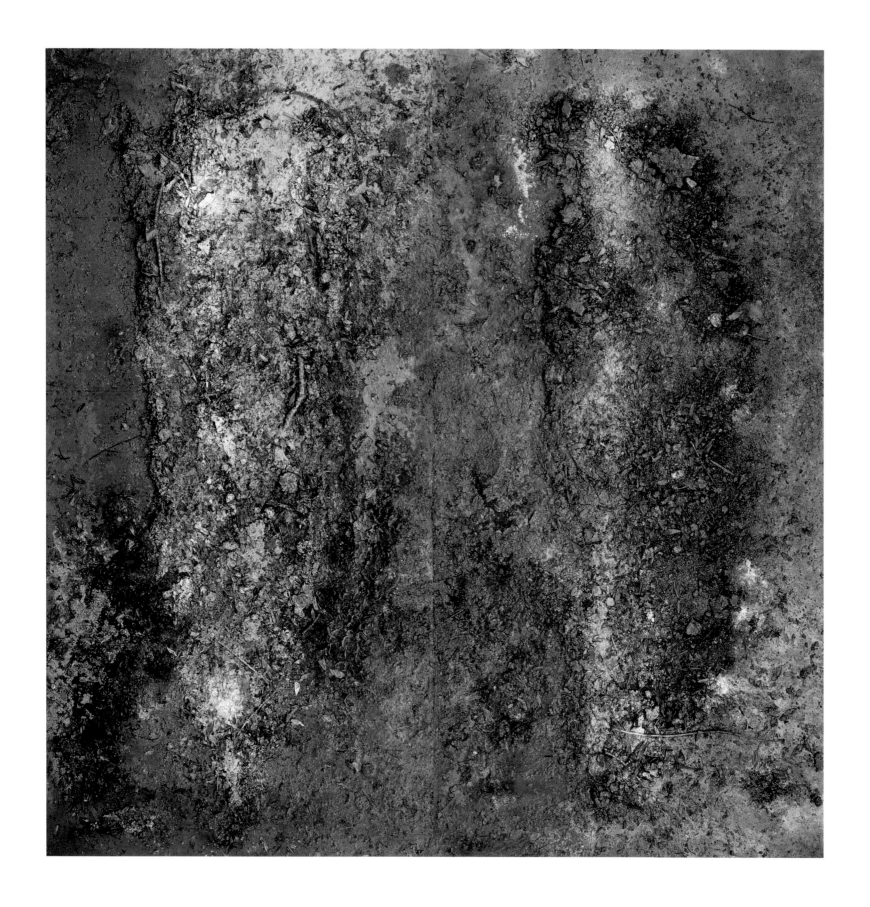

25. Bubble Room

43 x 29 in.

(109.2 x 73.7 cm)

1995

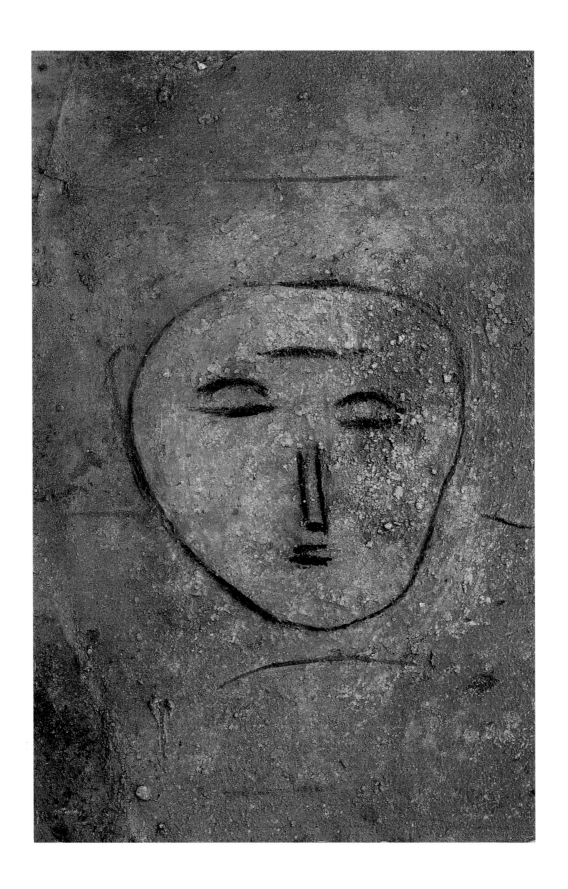

26. Metaphysical Bicycle I

53 x 39 in.

(134.6 x 99 cm)

1990

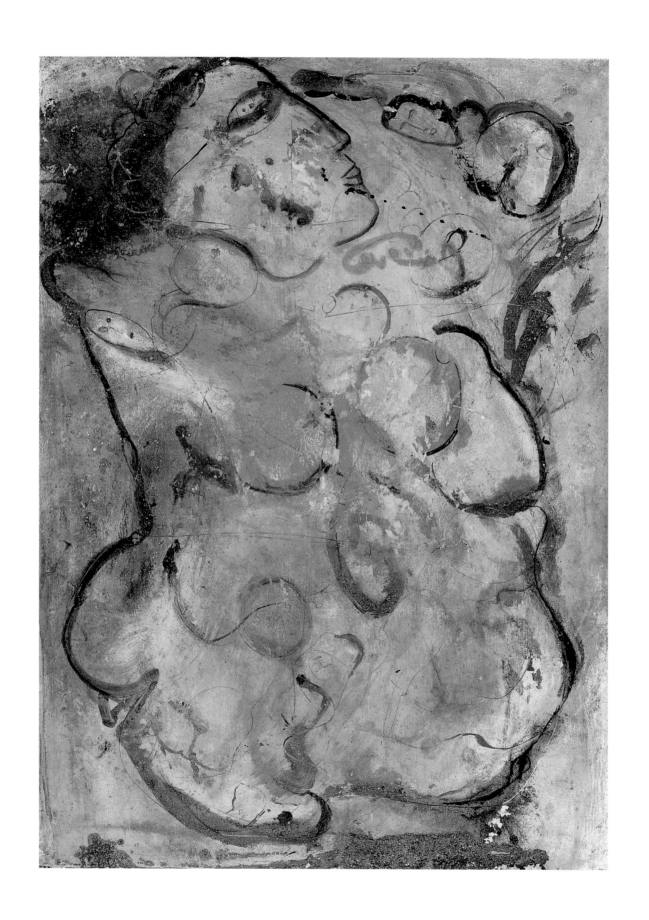

27. Zen Mouse

53 x 39 in.

(134.6 x 99 cm)

1986

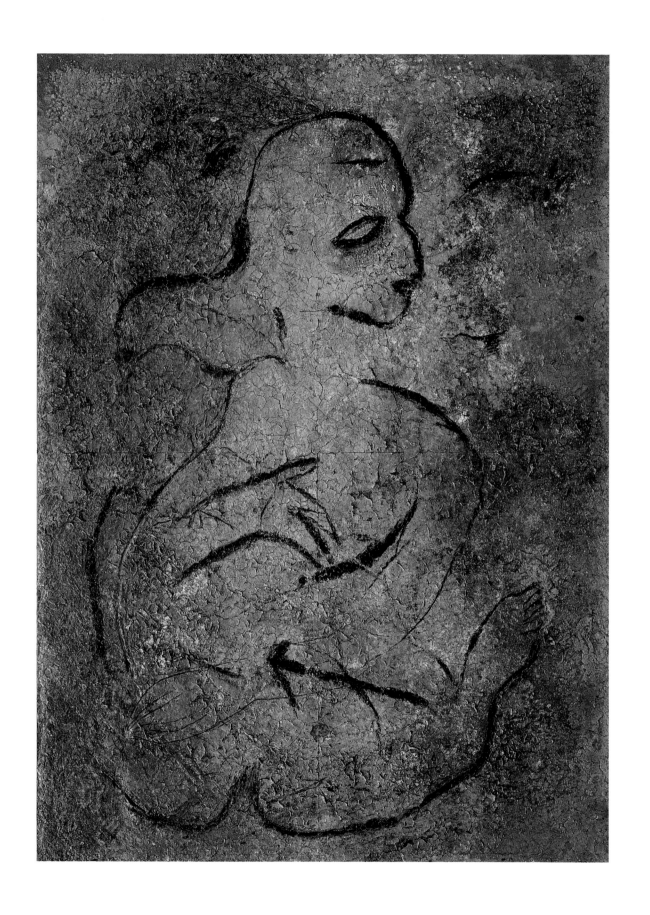

28. Profile

26 x 20 in.

(66 x 50.8 cm)

1988

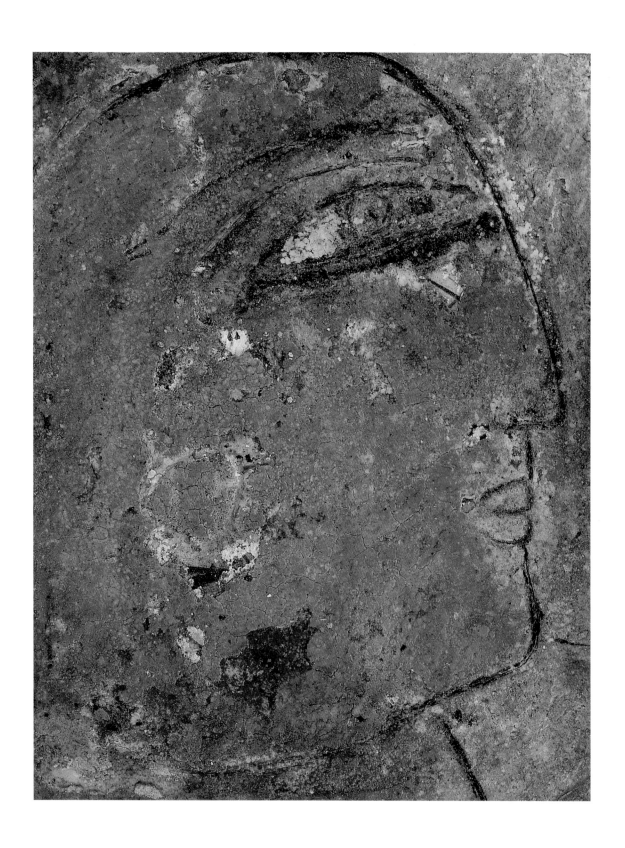

29. Ragamala in Rajasthan I

26 x 20 in.

(66 x 50.8 cm)

1988

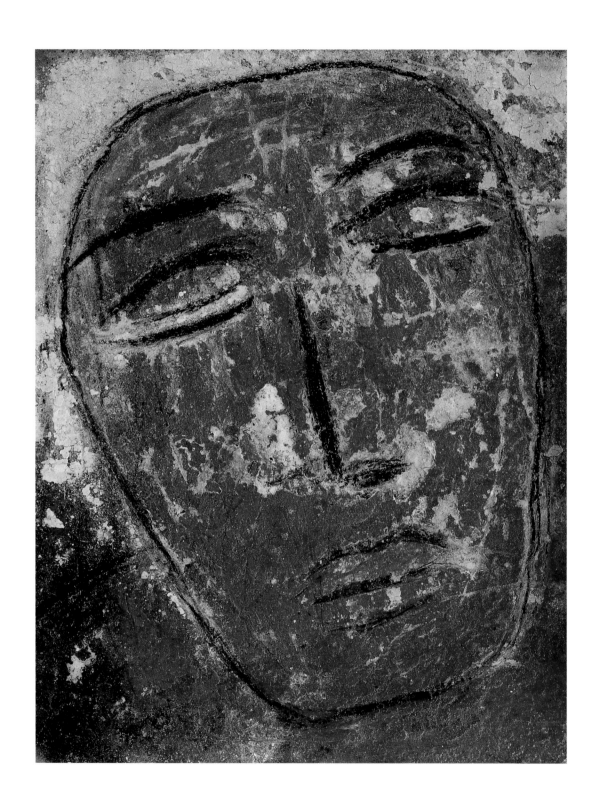

30. Ragamala in Rajasthan II

26 x 20 in.

(66 x 50.8 cm)

1988

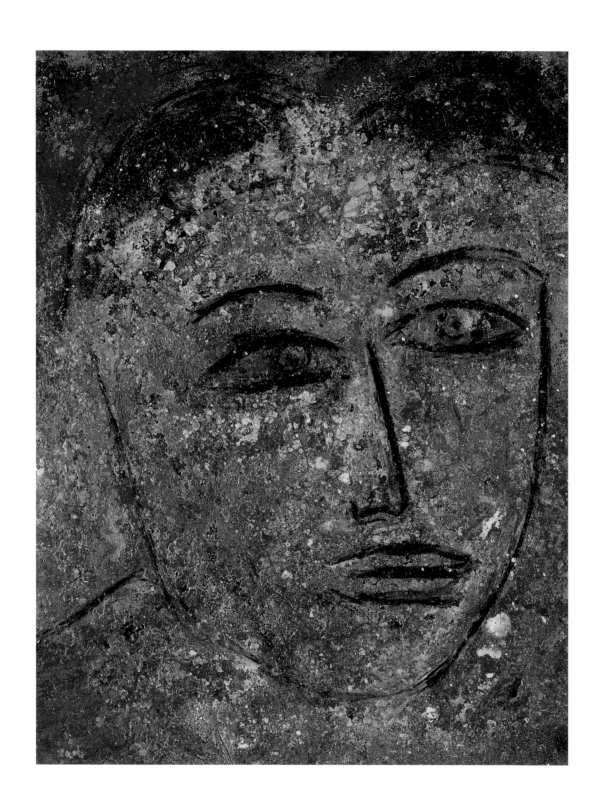

31. Cherokee Chief

80 x 63 in.

(203.2 x 160 cm)

1985

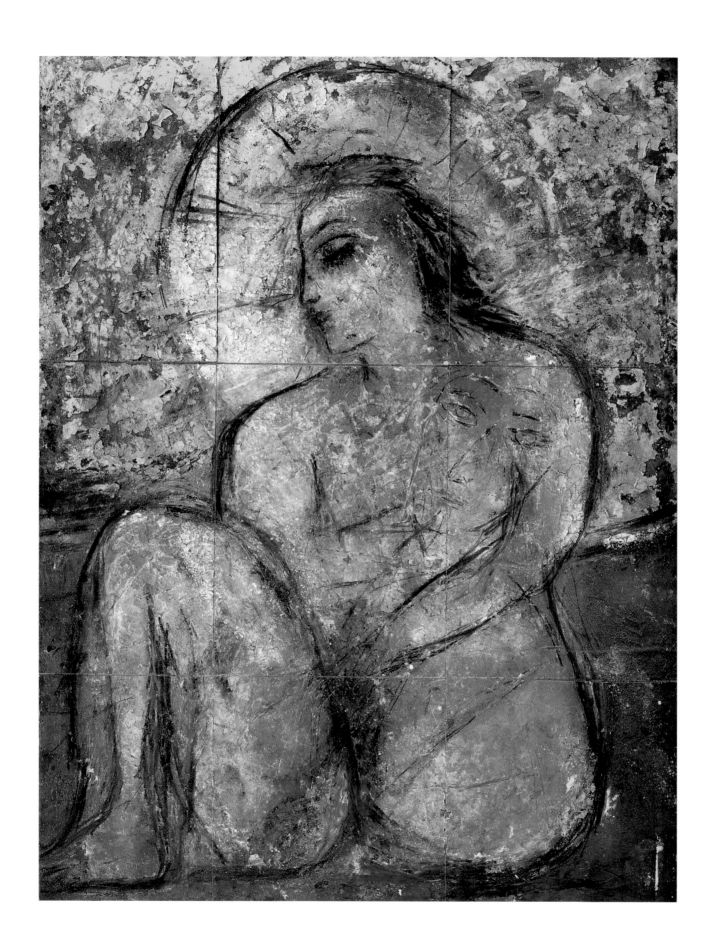

32. Meditation

60 x 84 in.

(152.4 x 213.4 cm)

1989

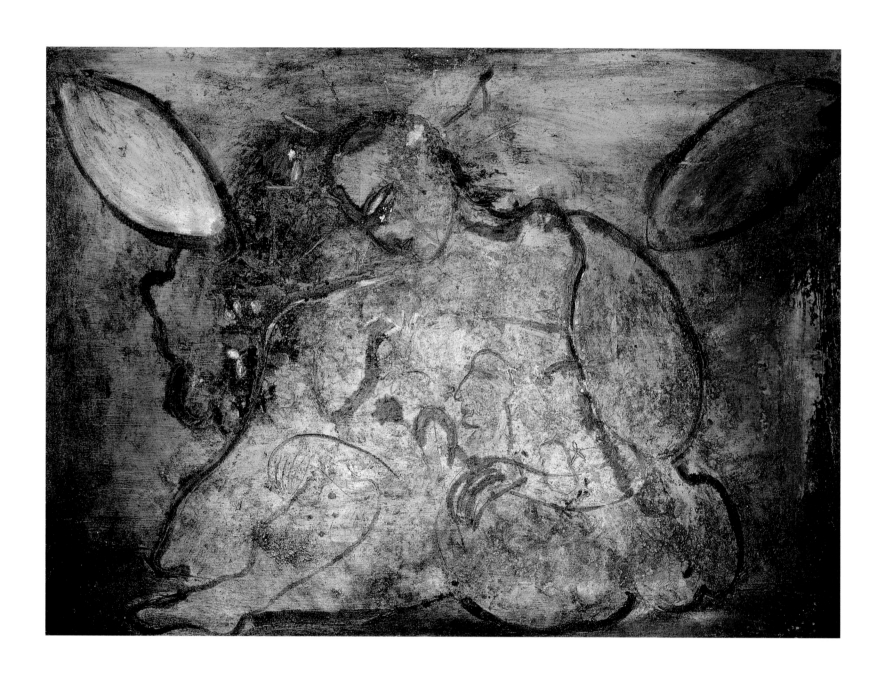

33. *Susst*

84 x 60 in.

(213.4 x 152.4 cm)

1988

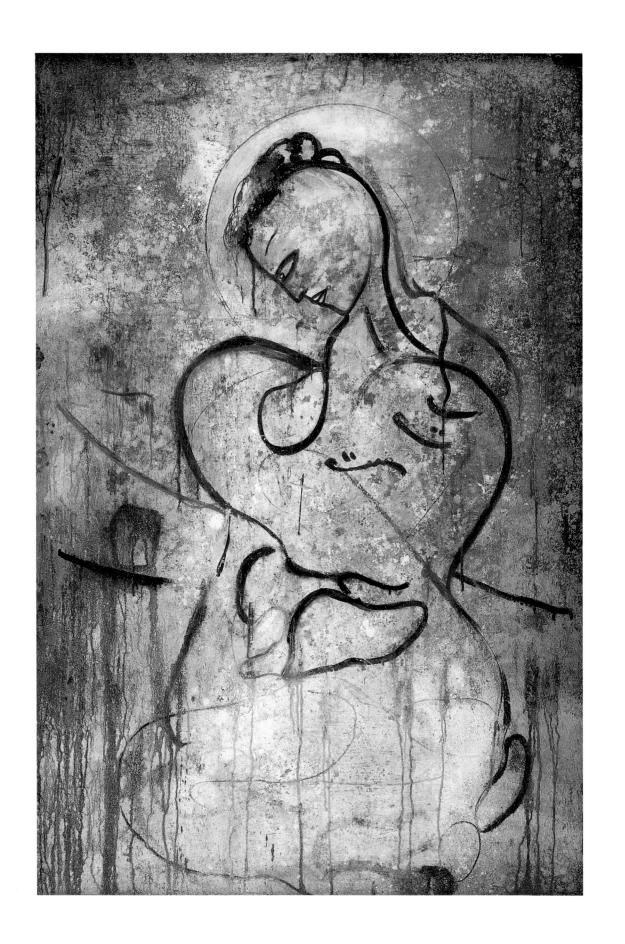

34. Earthman

58 x 108 in.

(147.3 x 274.3 cm)

1988

35. Phoenix

60 x 120 in.

(152.4 x 304.8 cm)

1994

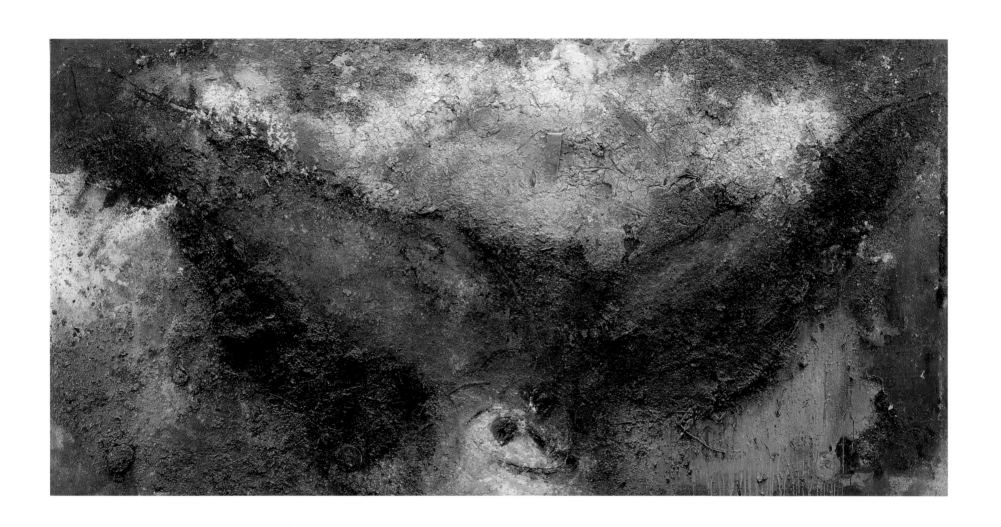

36. New York Window II

57 x 107 in.

(144.8 x 271.8 cm)

1986

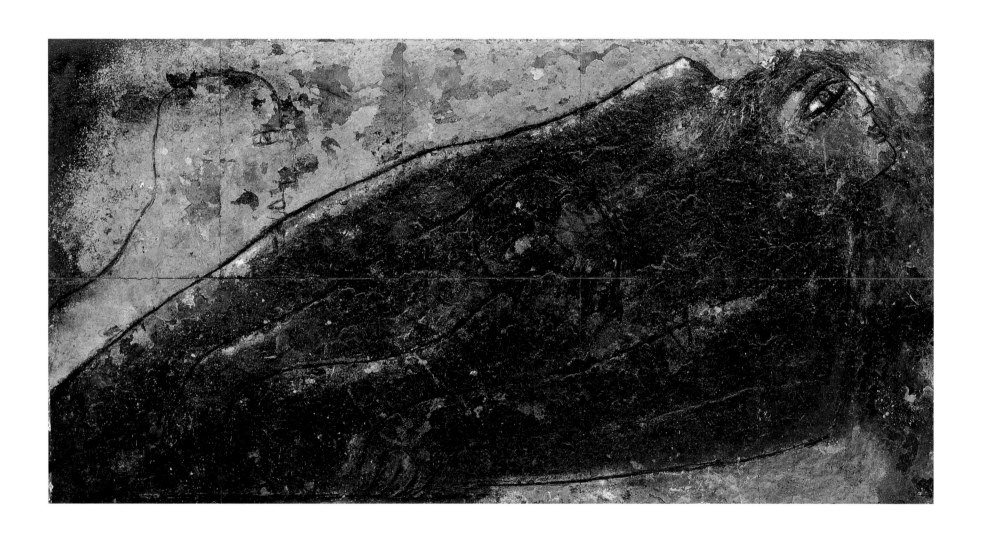

37. Sufi-Gee I

84 x 60 in.

(213.4 x 152.4 cm)

1990

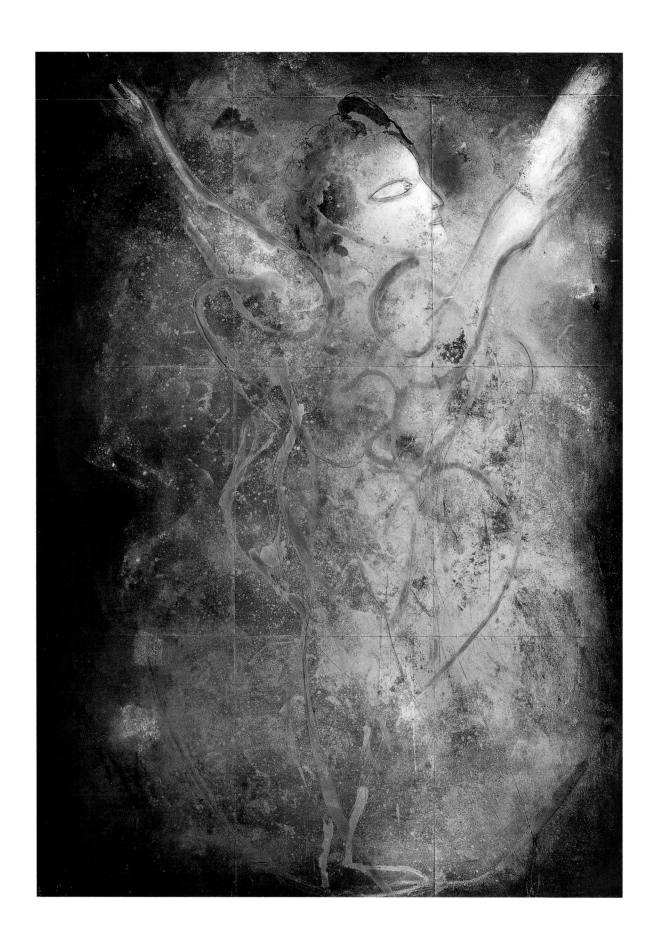

38. Metaphysical Painting

84 x 60 in.

(213.4 x 152.4 cm)

1989

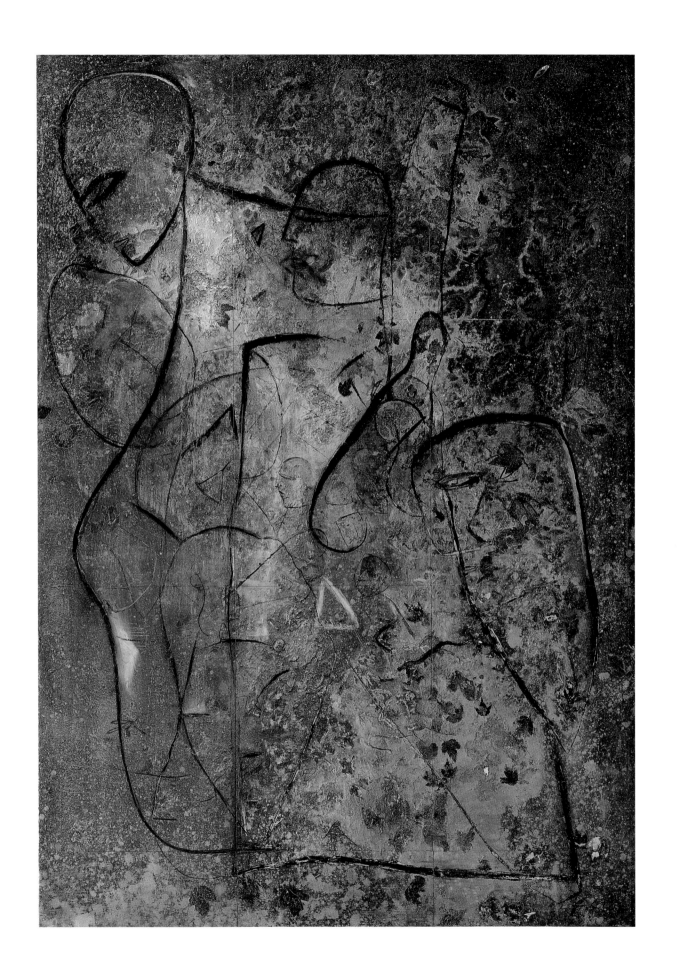

39. New York Window I

57 x 107 in.

(144.8 x 271.8 cm)

1985

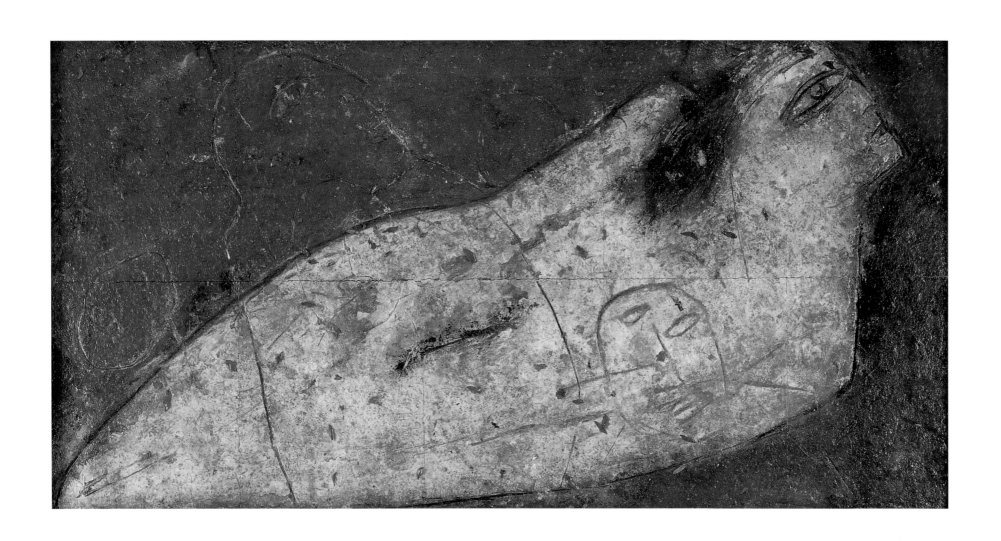

40. Age of Science

84 x 60 in.

(213.4 x 152.4 cm)

1995

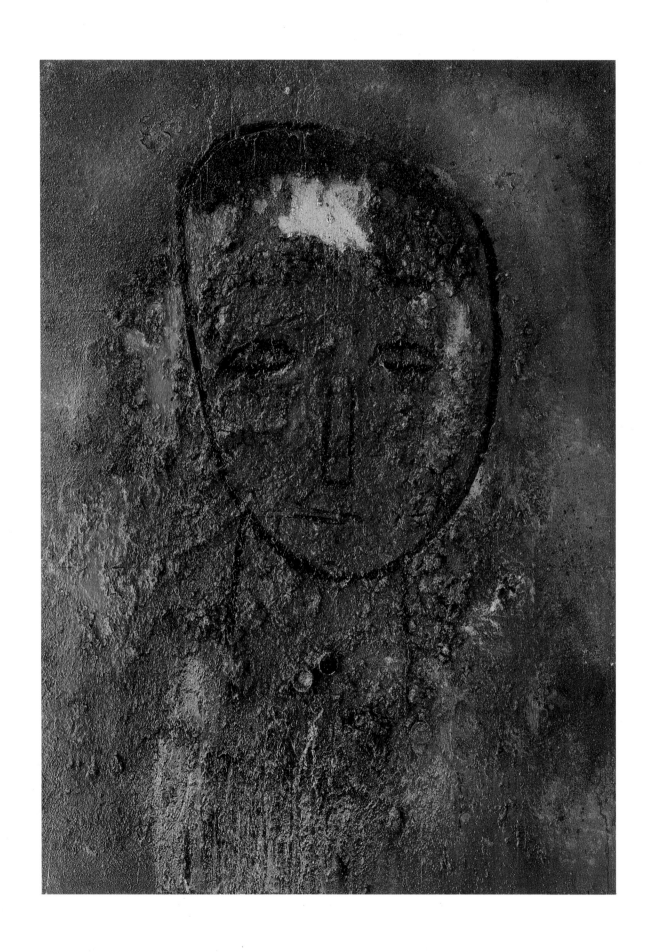

41. Mask

80 x 60 in.

(203.2 x 152.4 cm)

1995

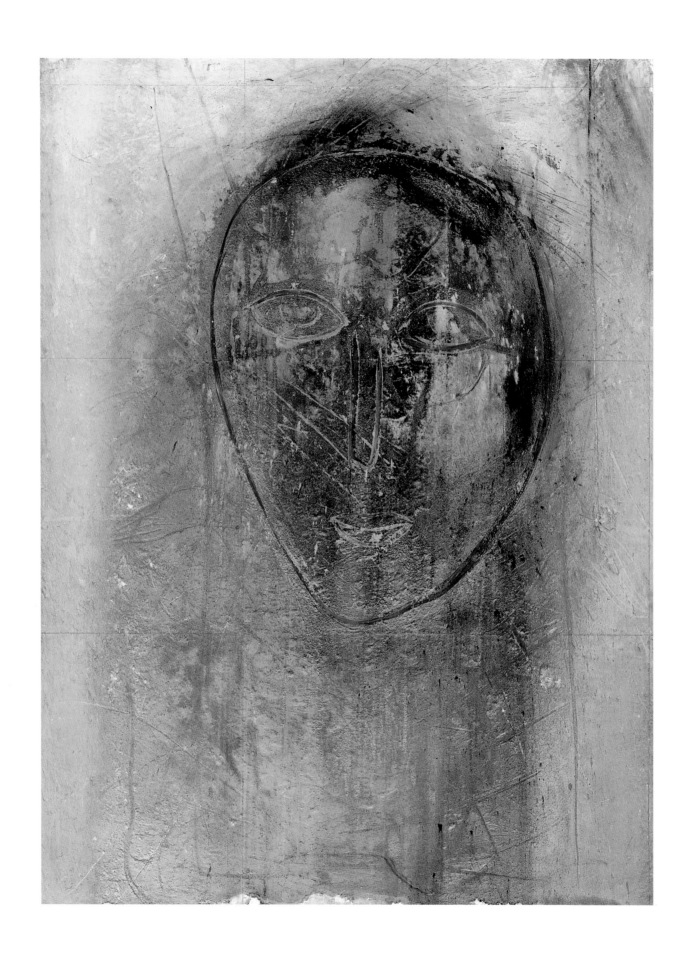

42. King Nunn Nunn

84 x 60 in.

(213.4 x 152.4 cm)

1995

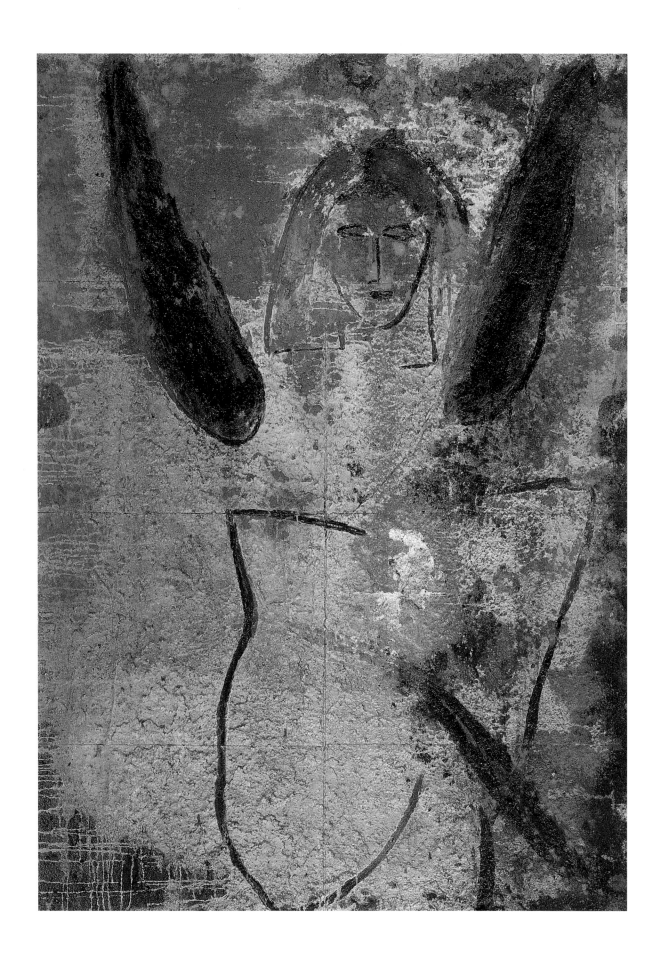

43. Dead Man Walking

84 x 60 in.

(213.4 x 152.4 cm)

1987

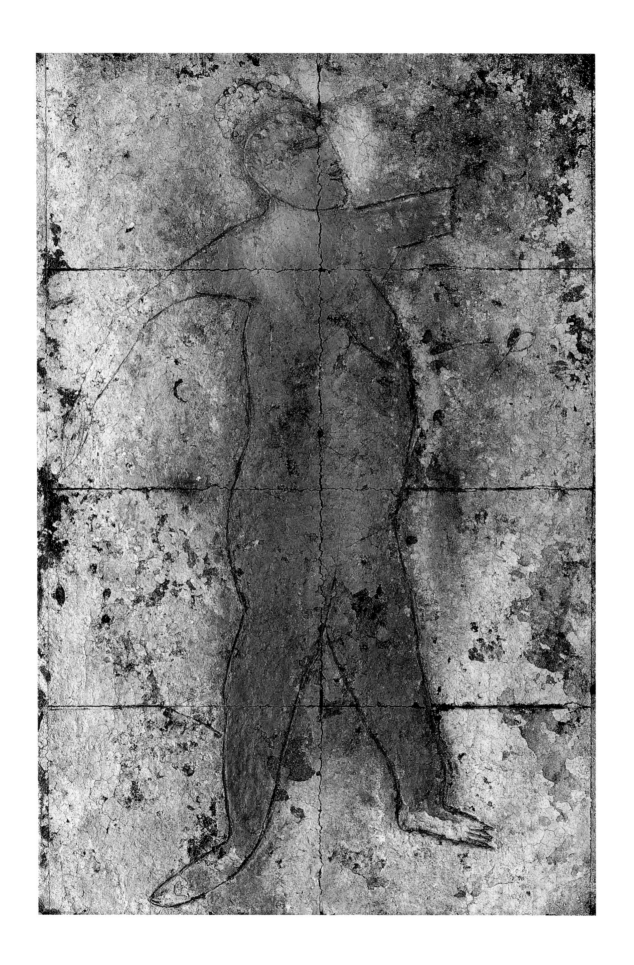

44. Event Horizon

60 x 120 in.

(152.4 x 304.8 cm)

1995

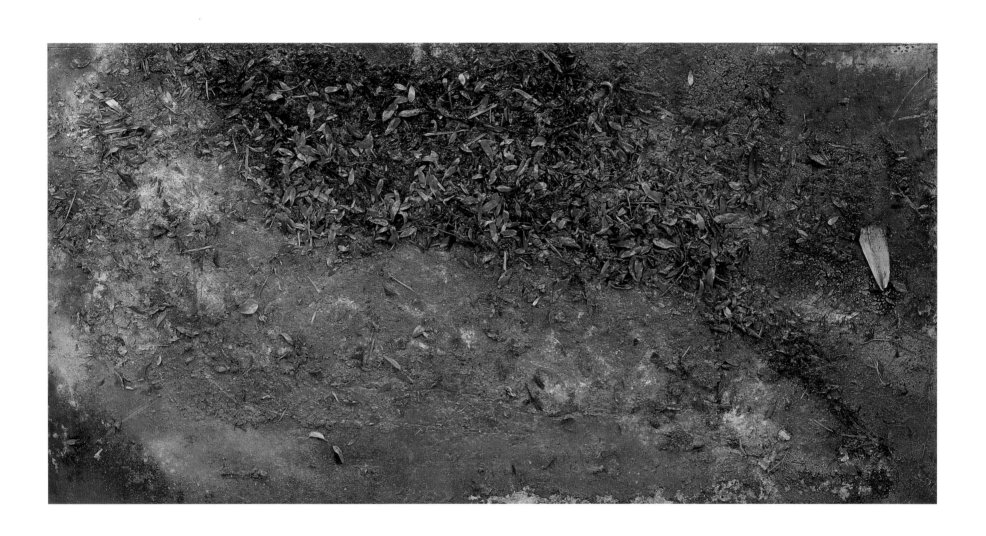

OILS ON LINEN

1995-1996

45. Haiya-Haiya II

80 x 60 in.

(203.2 x 152.4 cm)

1996

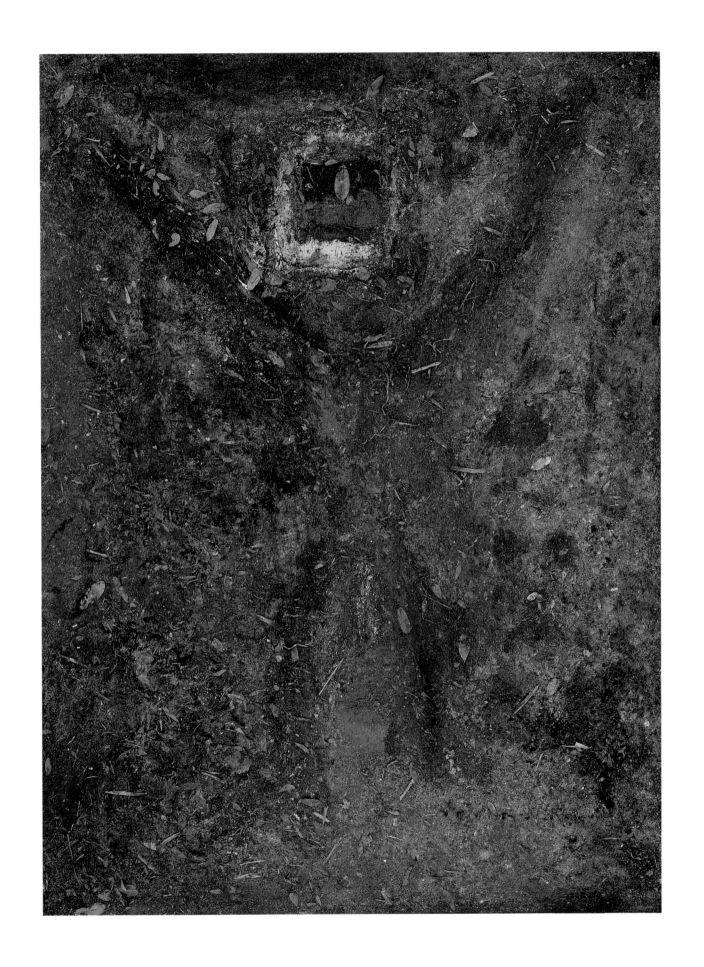

46. Haiya-Haiya I

80 x 60 in.

(203.2 x 152.4 cm)

1996

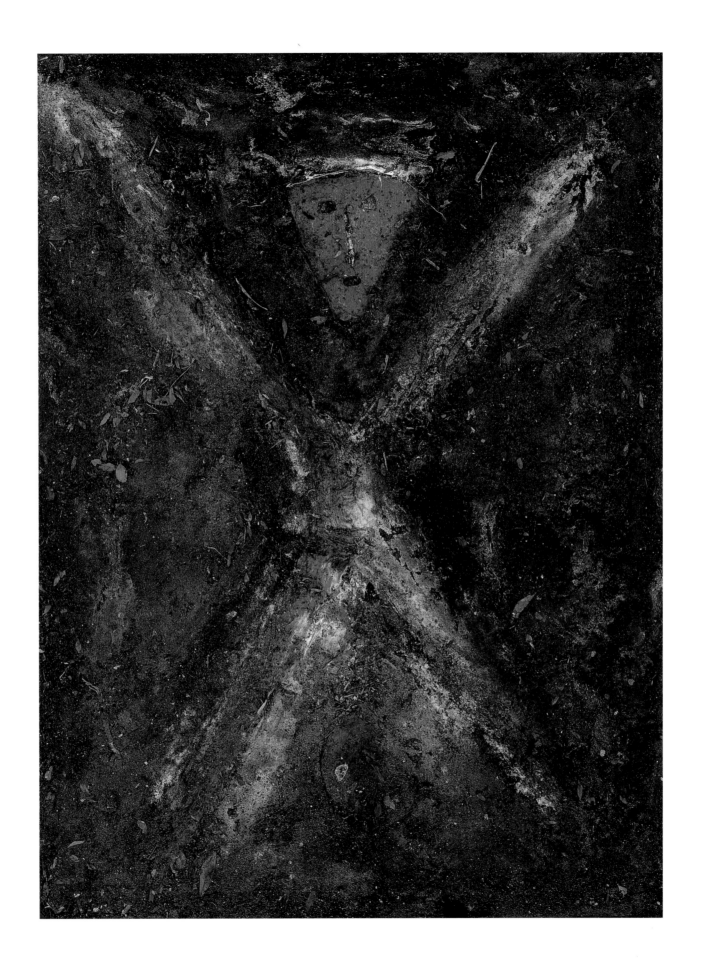

47. Panic / Bliss

84 x 60 in.

(213.4 x 152.4 cm)

1996

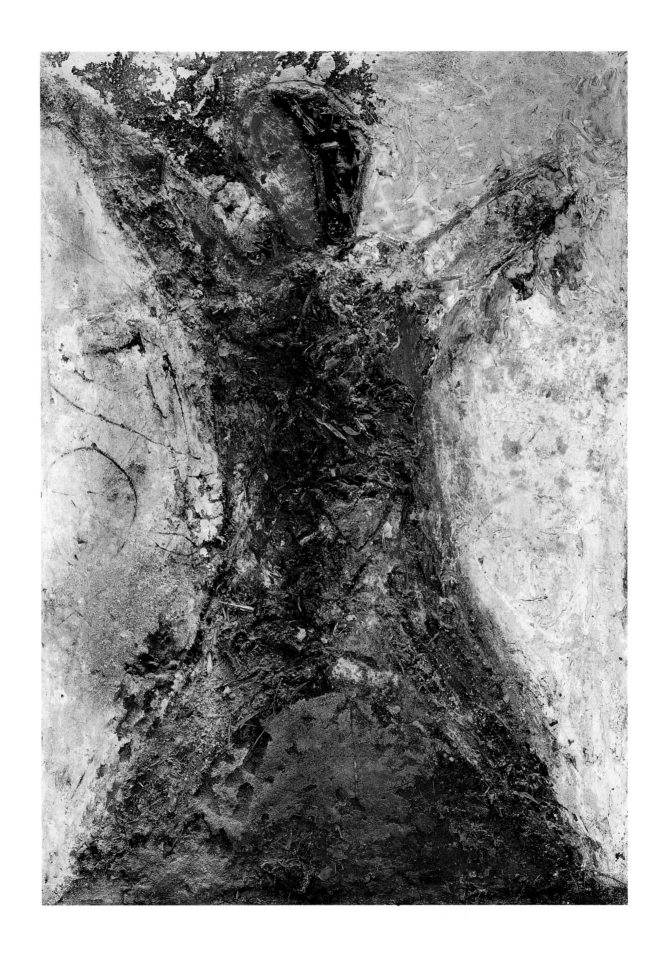

48. Torso V

60 x 84 in.

(152.4 x 213.4 cm)

1996

oil on prepared surface

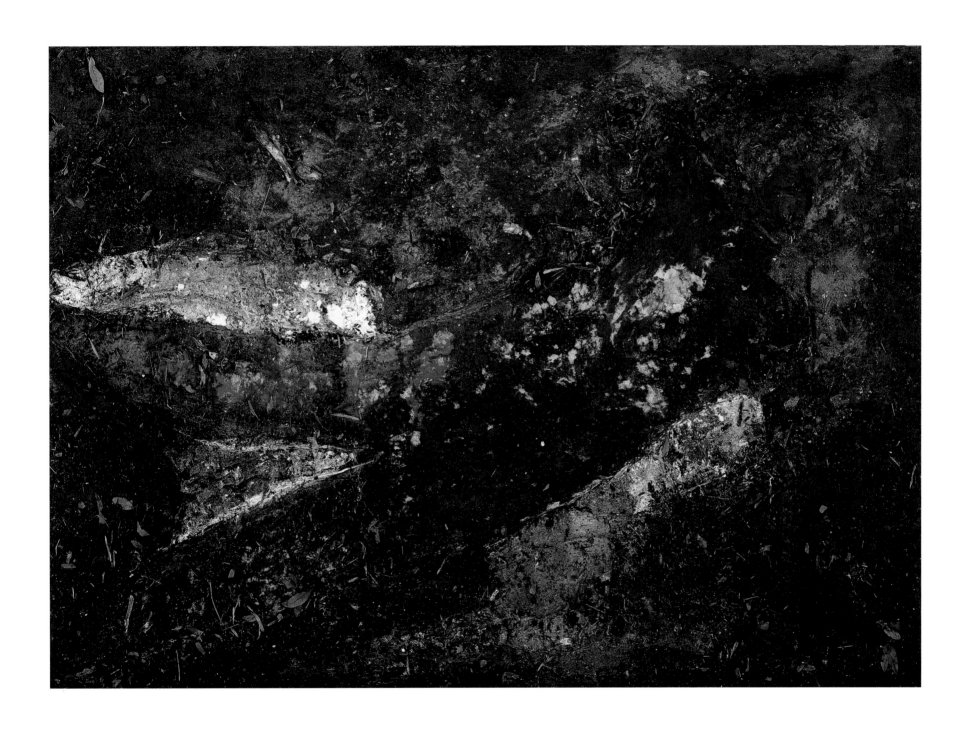

49. Backyard I

80 x 60 in.

(203.2 x 152.4 cm)

1996

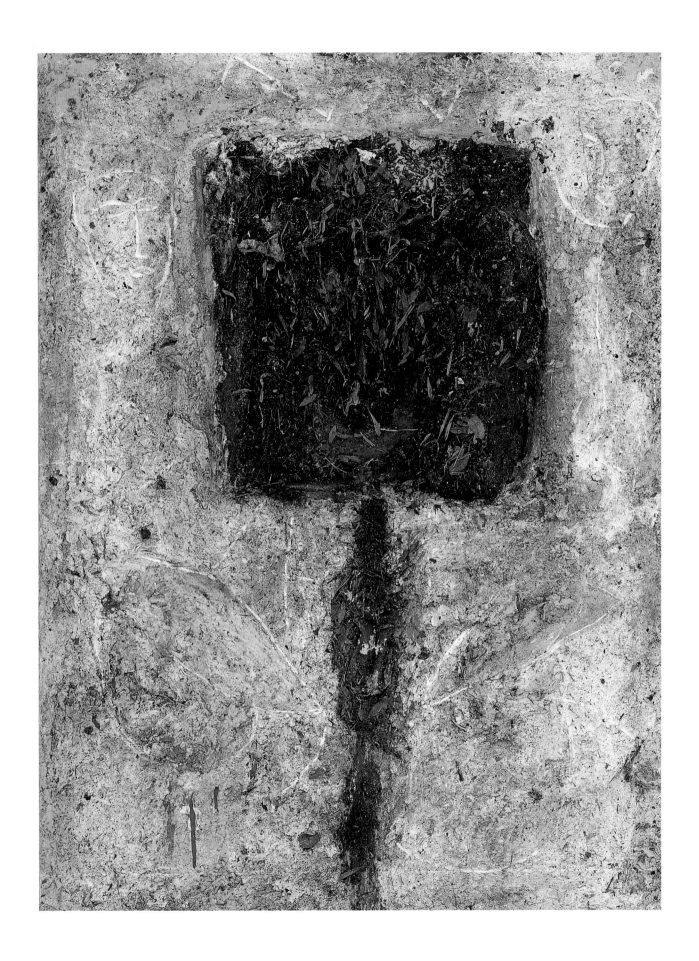

50. Suicide of Lucretia I

62 x 45 in.

(157.5 x 114.3 cm)

1996

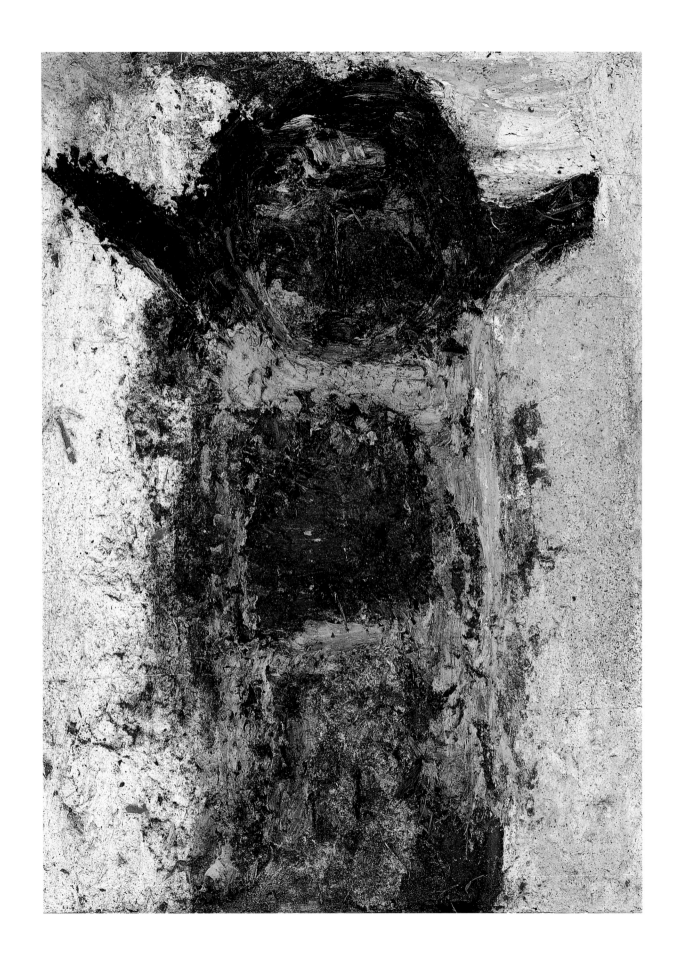

51. Torso IV

45 x 62 in.

(114.3 x 157.5 cm)

1996

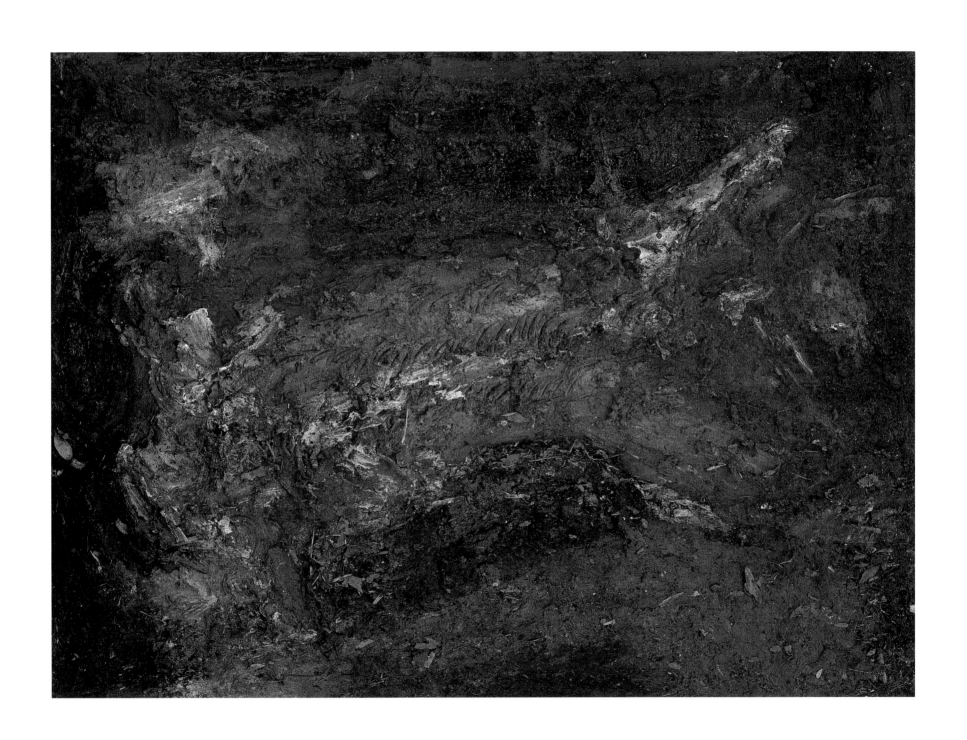

52. Tin Man

84 x 60 in.

(213.4 x 152.4 cm)

1996

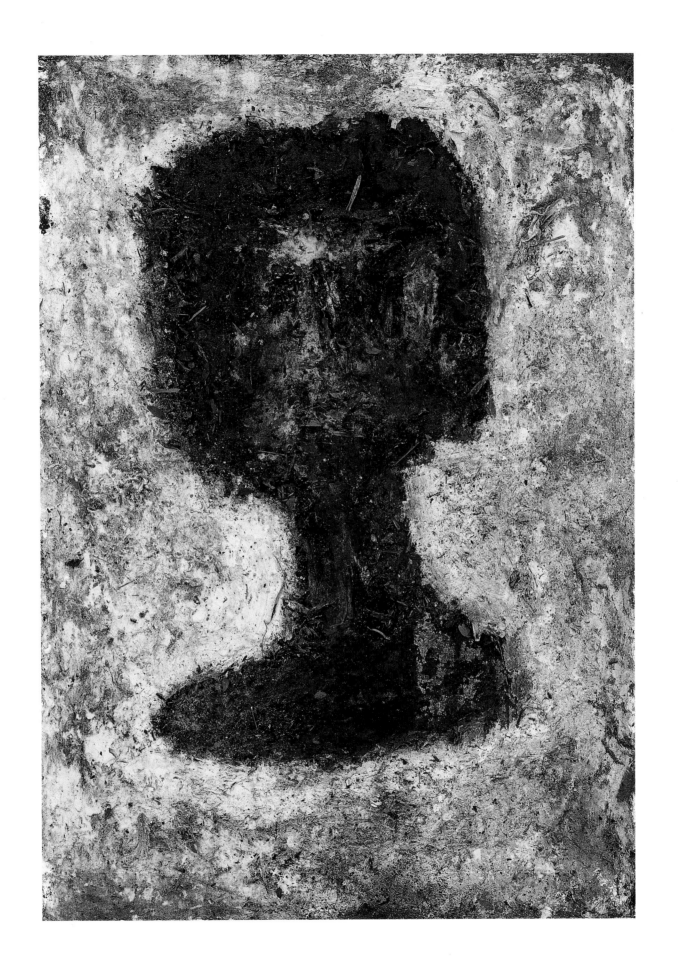

INDUSTRIAL PAINTS
ON CANVAS

1983-1985

53. The Sacrifice

96 x 144 in.

(243.9 x 365.8 cm)

1983

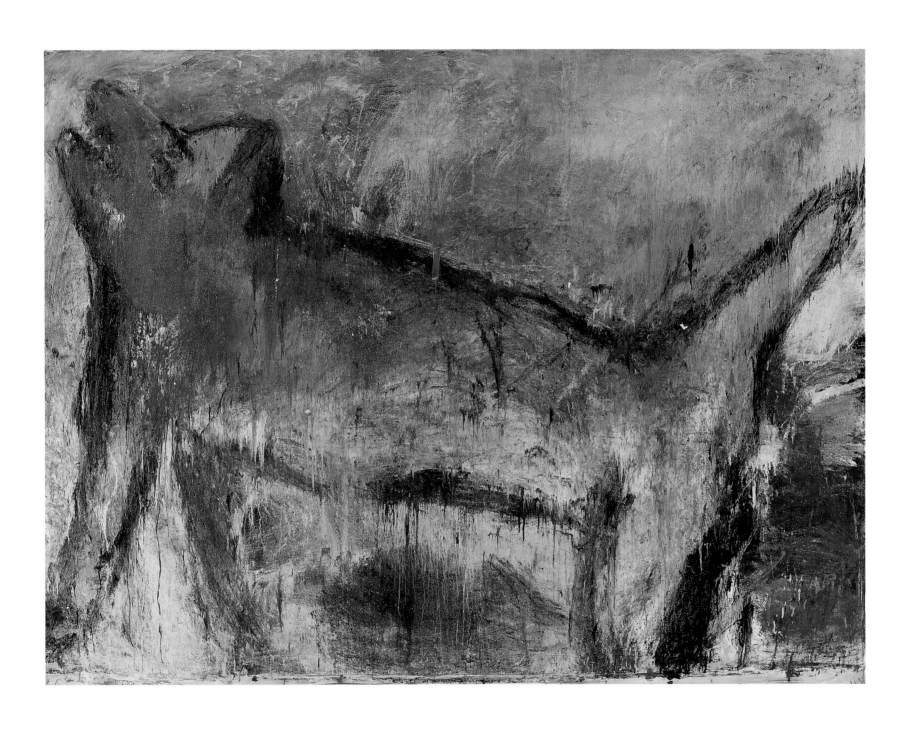

54. Suicide of Lucretia

96 x 144 in.

(243.9 x 365.8 cm)

1985

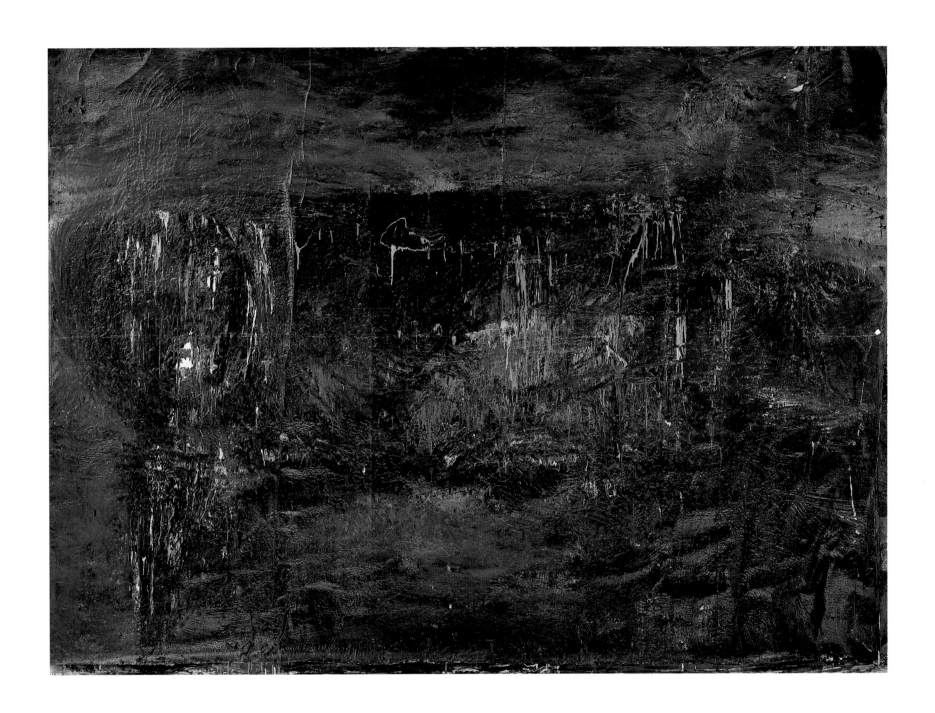

55. Homo Erectus

96 x 120 in.

(243.9 x 304.8 cm)

1985

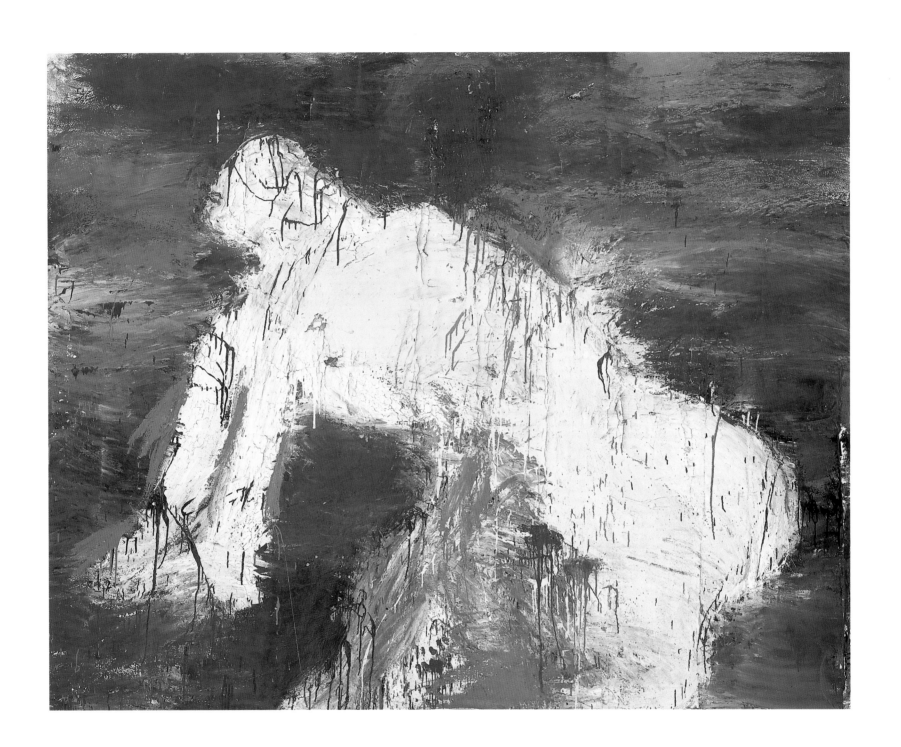

56. Divine Copulation with Death I

96 x 120 in.

(243.9 x 304.8 cm)

1985

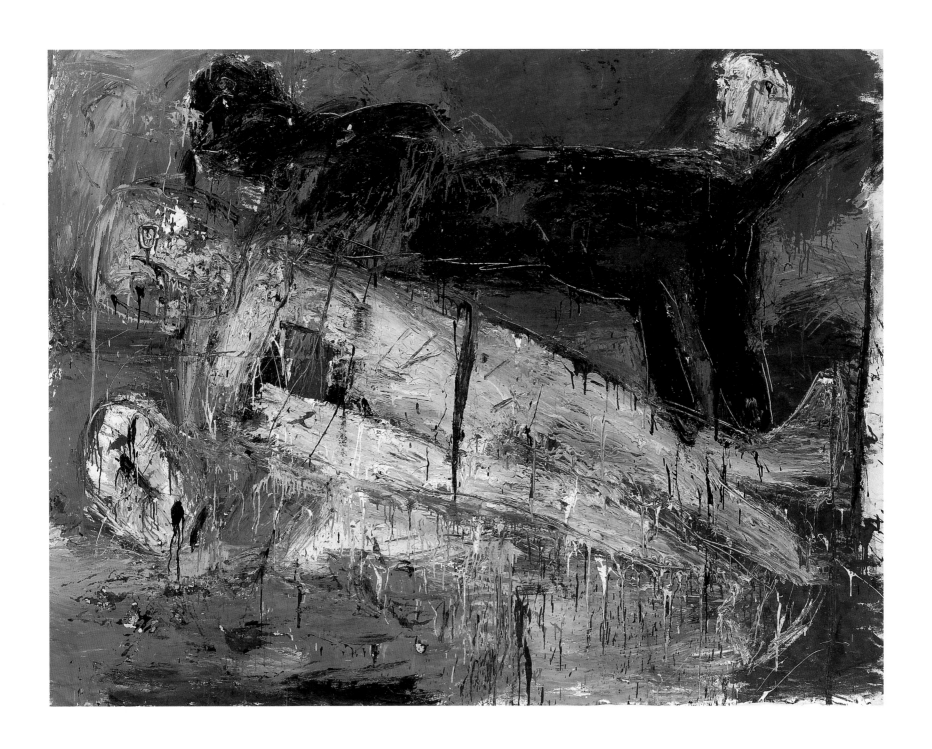

57. Mother

96 x 144 in.

(243.9 x 365.8 cm)

1985

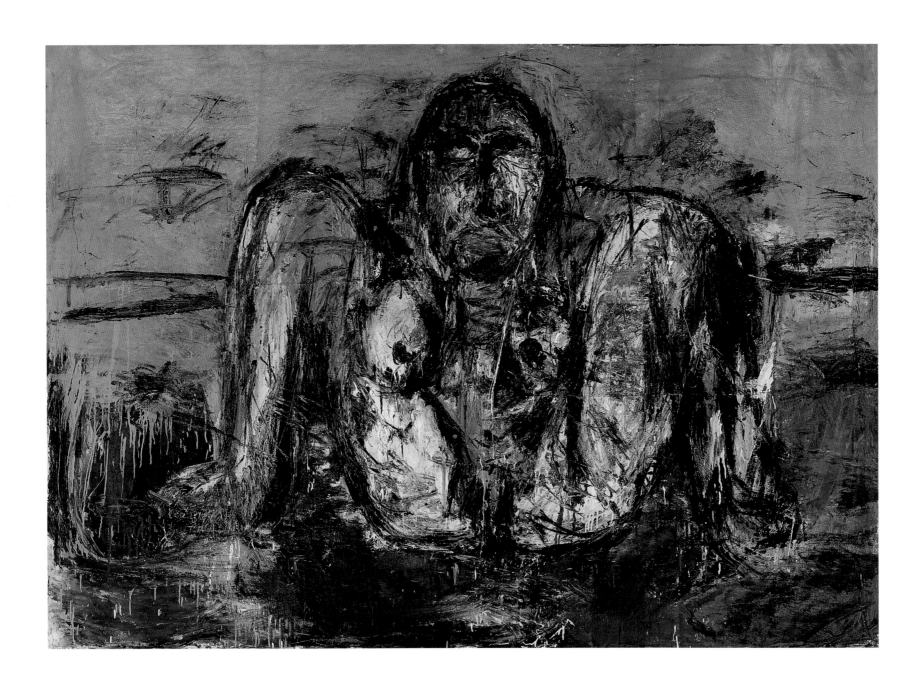

58. Divine Copulation with Death II

96 x 120 in.

(243.9 x 304.8 cm)

1985

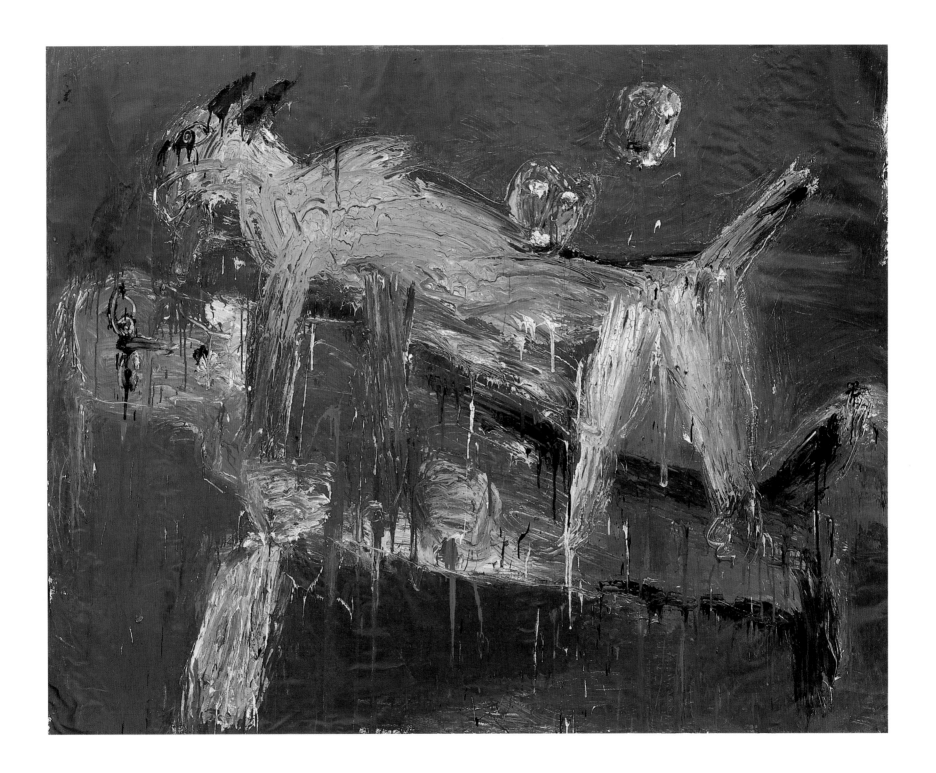

59. The Seventh Circle of Hell

96 x 120 in.

(243.9 x 304.8 cm)

1985

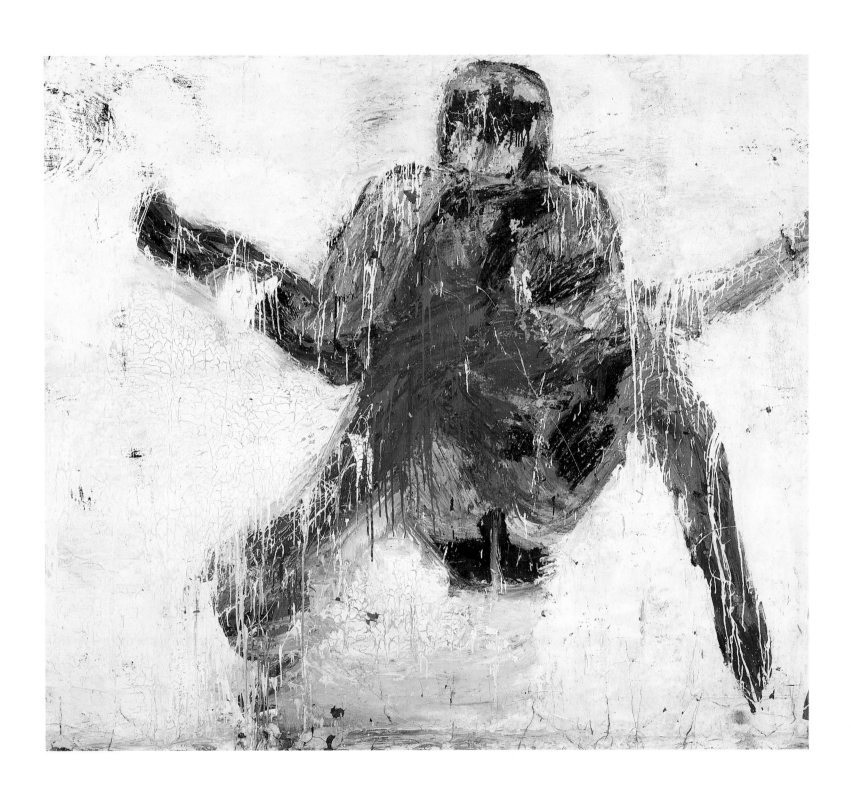

60. *Falling Figure*

96 x 144 in.
(243.9 x 365.8 cm)
1983

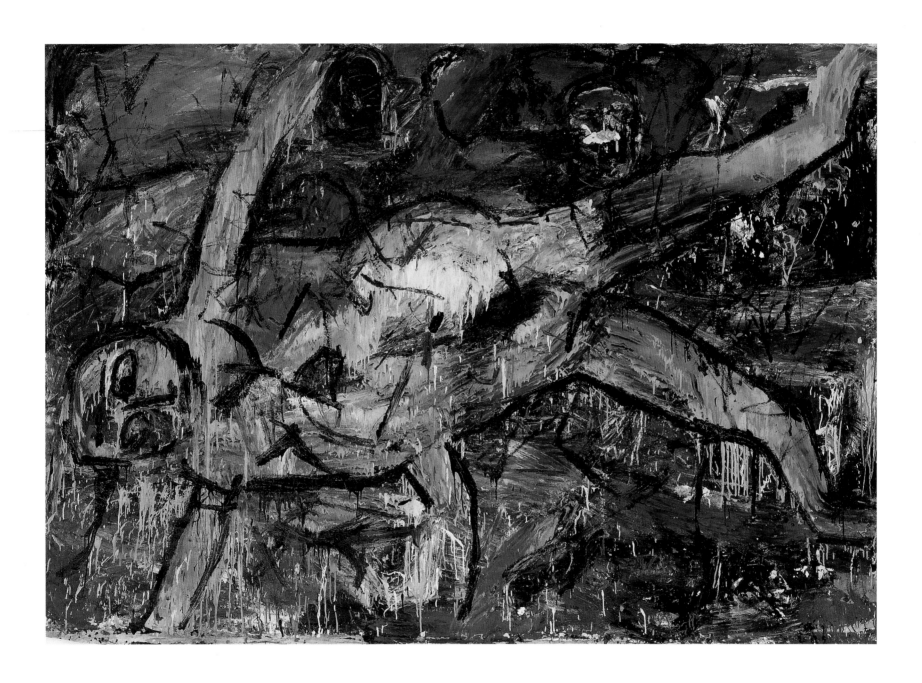

PIGMENTS ON PREPARED SURFACE

1976-1994

61. Sufi-Gee in the Evening

79 x 55 in.

(200.7 x 139.7 cm)

1994

pigments on canvas

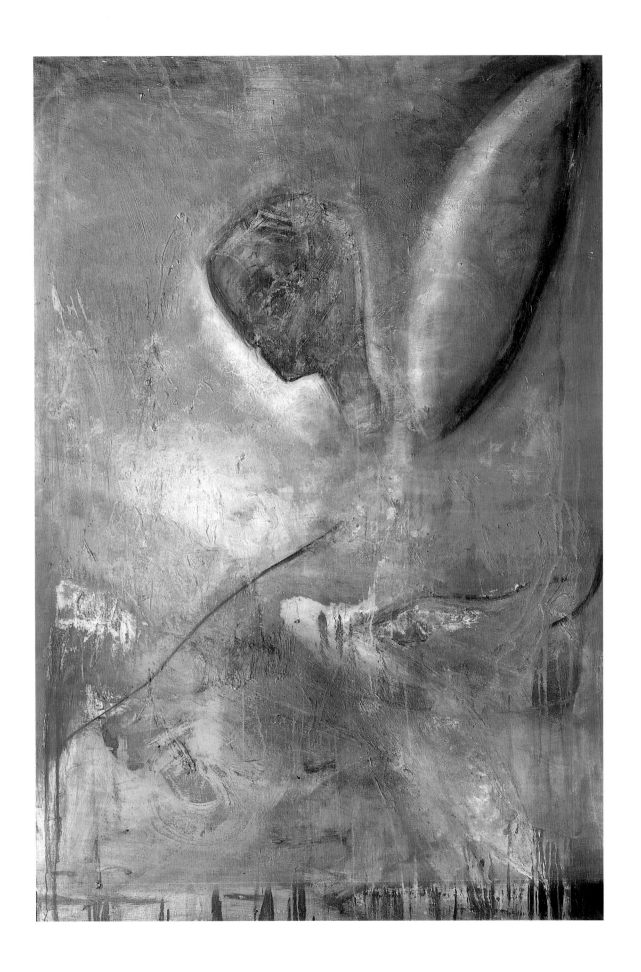

62. *Metaphysical Bicycle II*

53 x 39 in.

(134.6 x 99 cm)

1990

pigments on paper

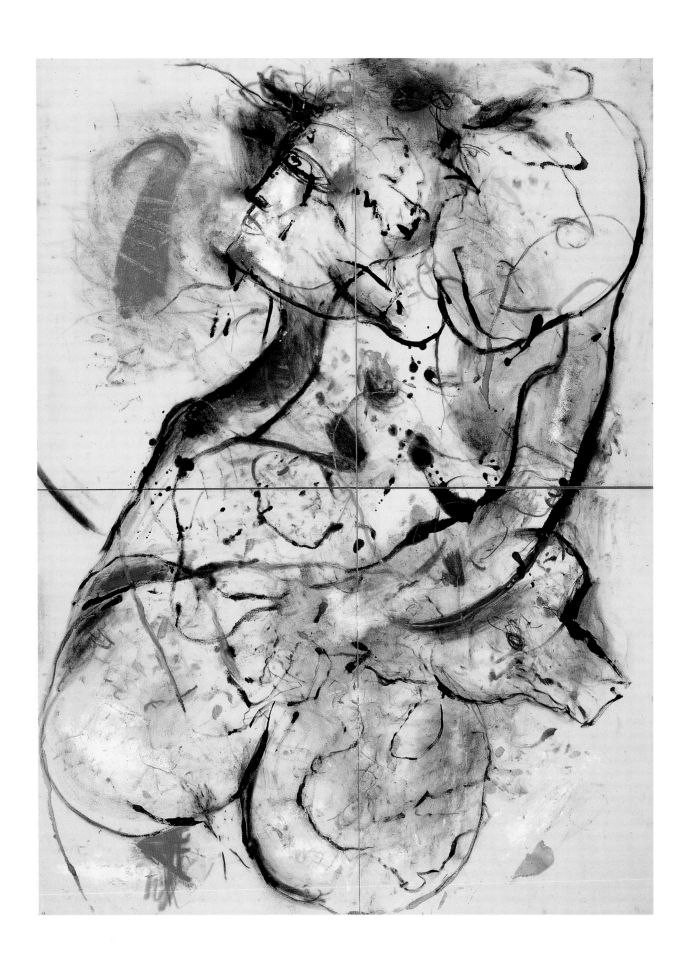

63. The Poet

26 x 20 in.

(66 x 50.8 cm)

1986

pigments on paper

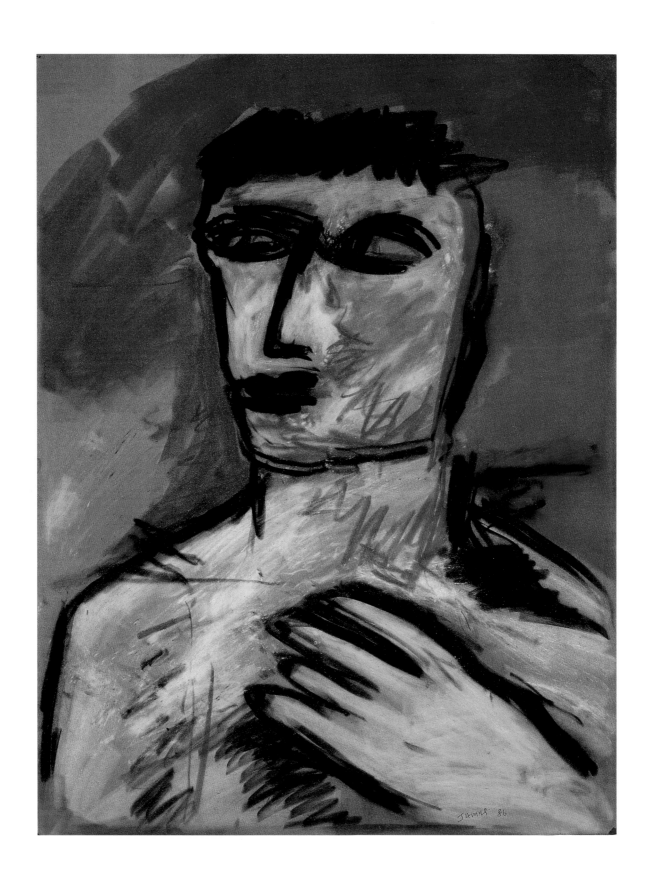

64. Butterfly of Kathmandu

60 x 120 in.

(152.4 x 304.8 cm)

1991

pigments on canvas

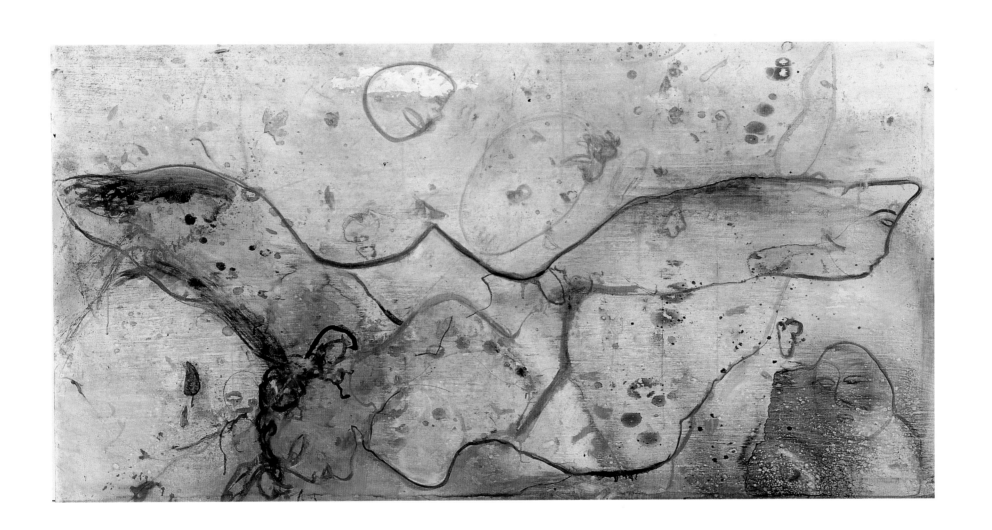

65. *The Pointing Finger*

26 x 20 in.

(66 x 50.8 cm)

1976

pigments on paper

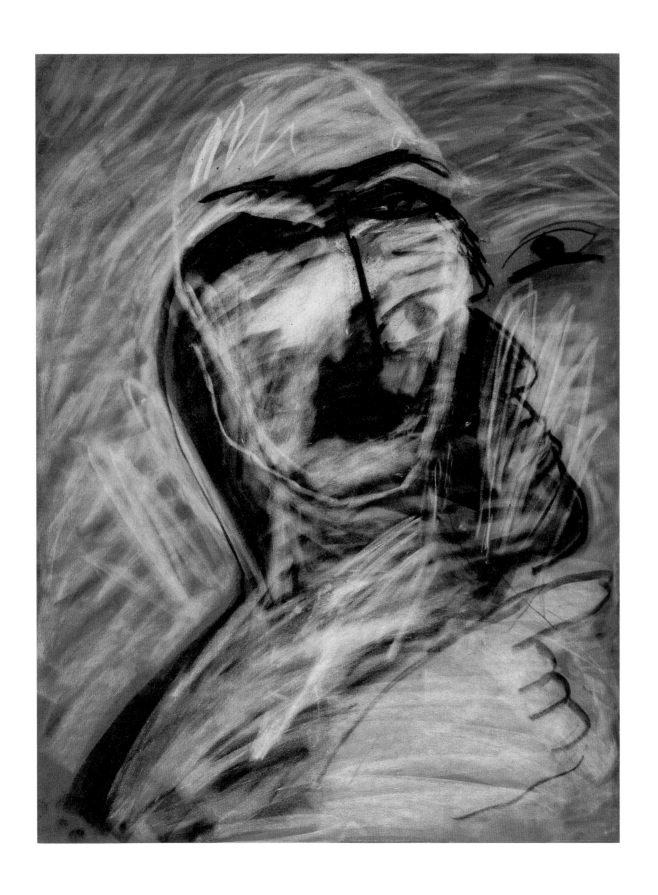

PIGMENTATION
ON CORK
1993-1996

66. Gate to Paradise

75 x 52 in.

(190.5 x 132 cm)

1994

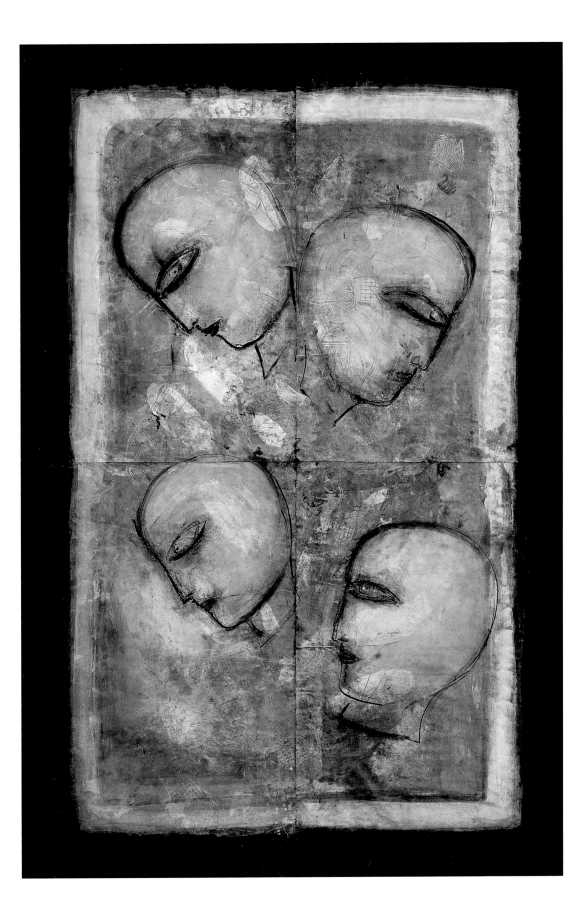

67. White Surface

79 x 55 in.

(200.7 x 139.7 cm)

1994

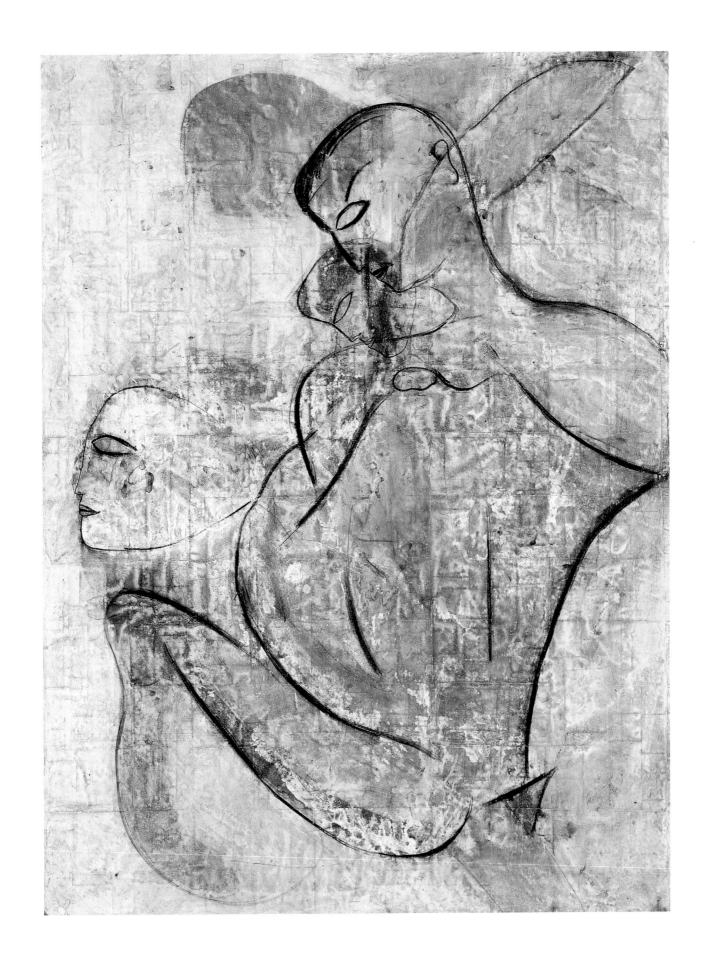

68. Manu

58 x 39 in.

(147.3 x 99 cm)

1996

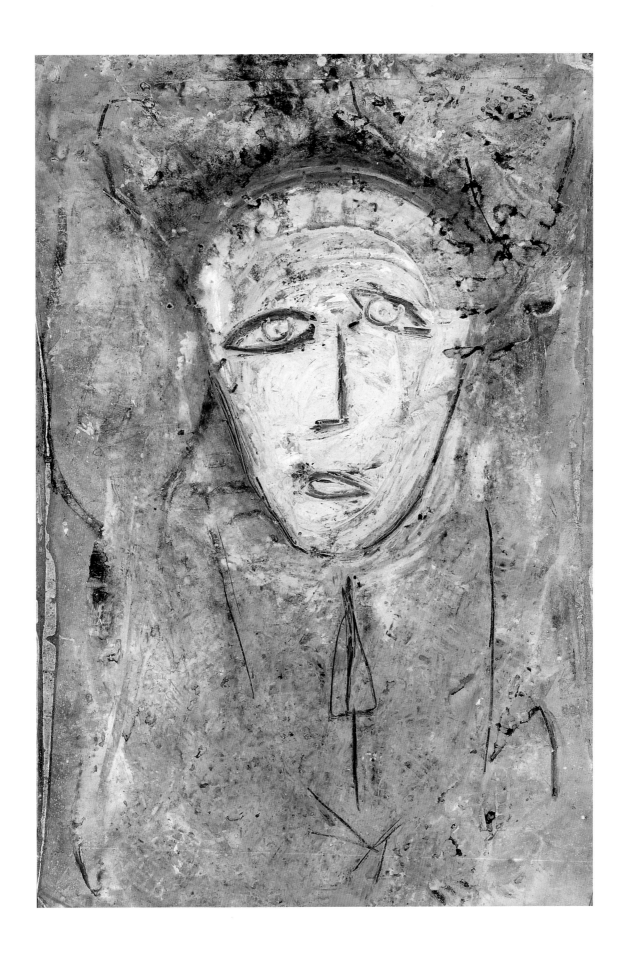

69. Tantra Monkey

45 x 45 in.

(114.3 x 114.3 cm)

1996

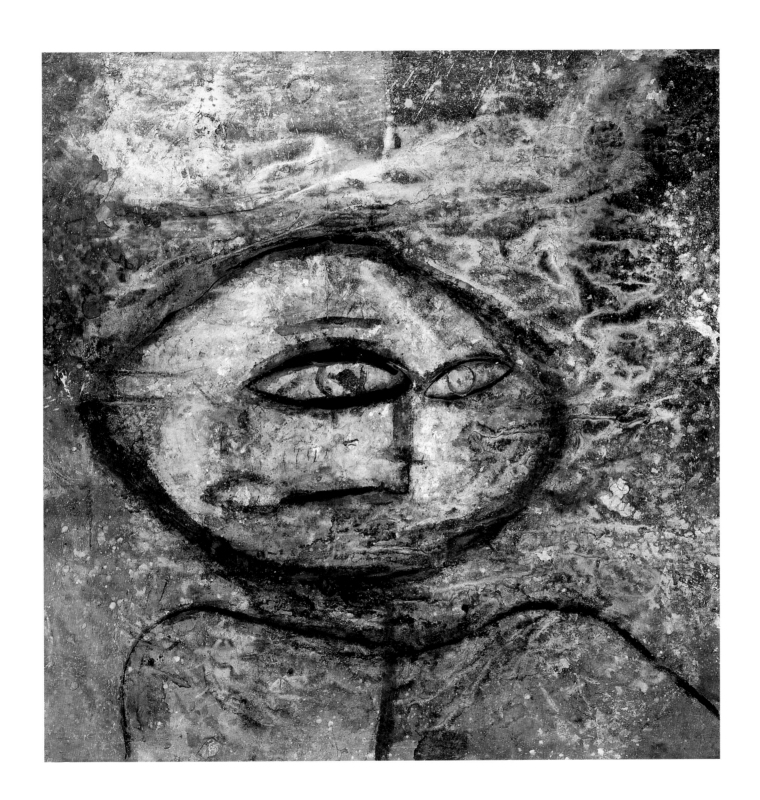

70. Play Triptych

79 x 56 in. each panel

(200.7 x 142.2 cm) each panel

1993

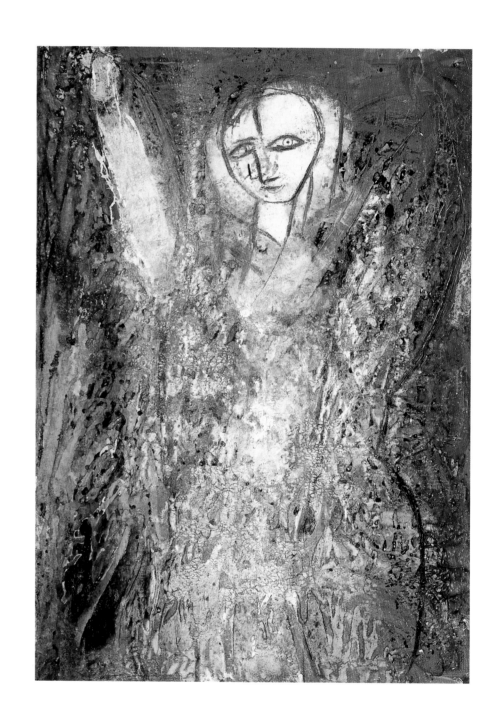

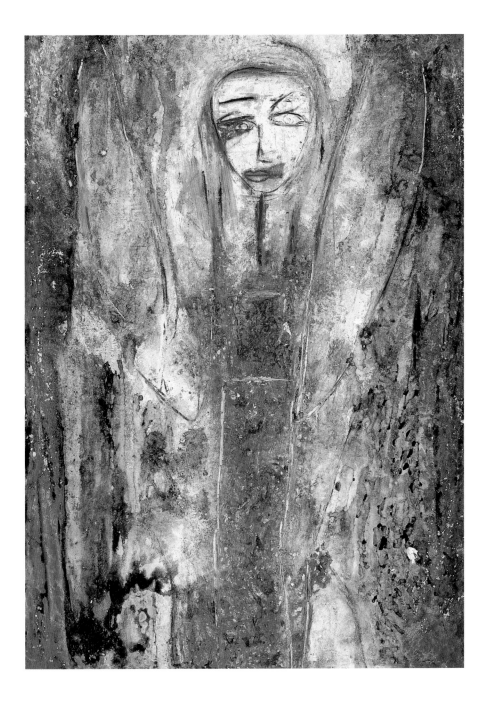
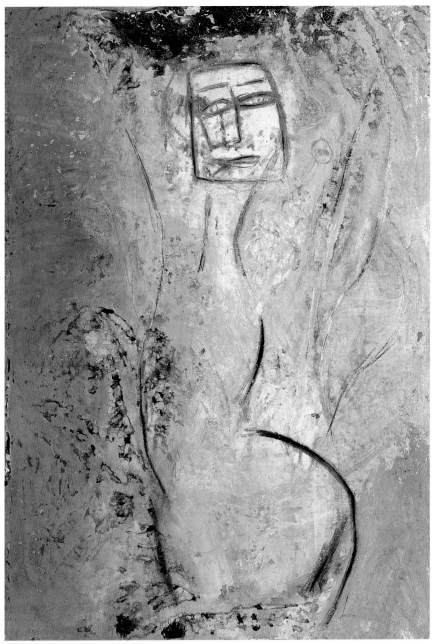

71. Hero

97 x 55 in.

(246.38 x 139.70 cm)

1996

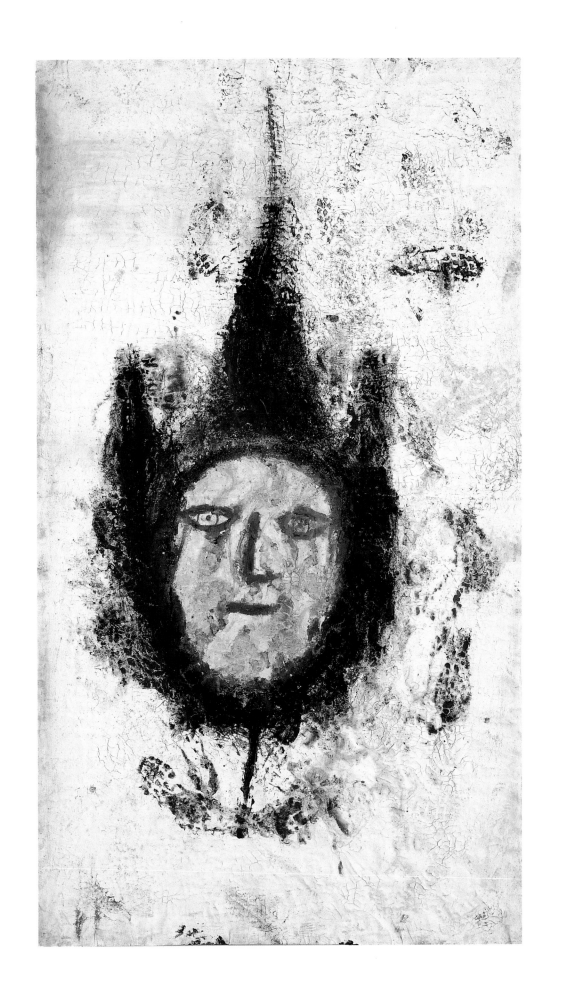

72. Shaman Triptych

79 x 56 in. each panel
(200.7 x 142.2 cm) each panel
1996

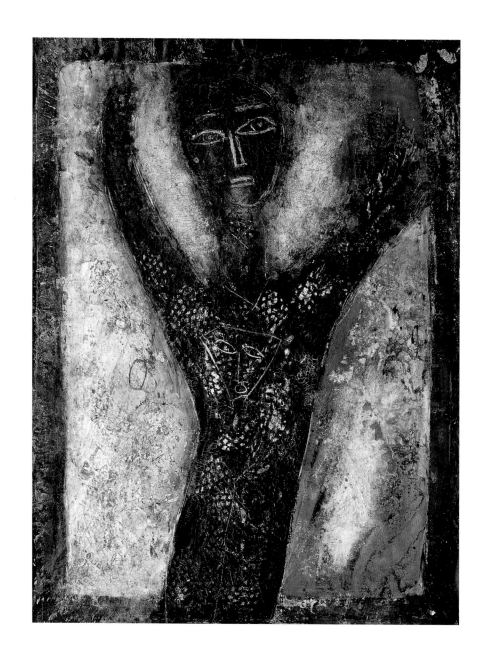

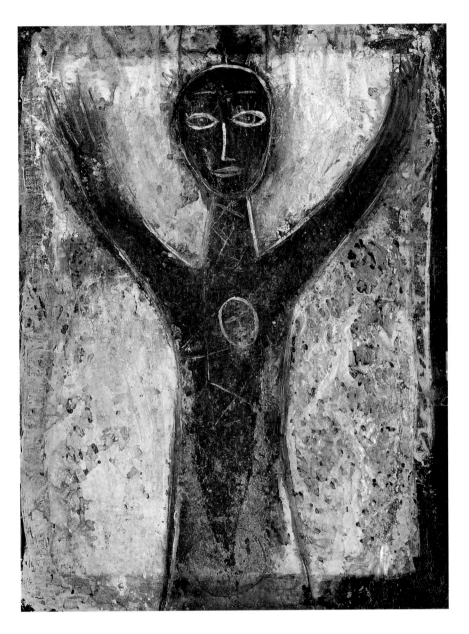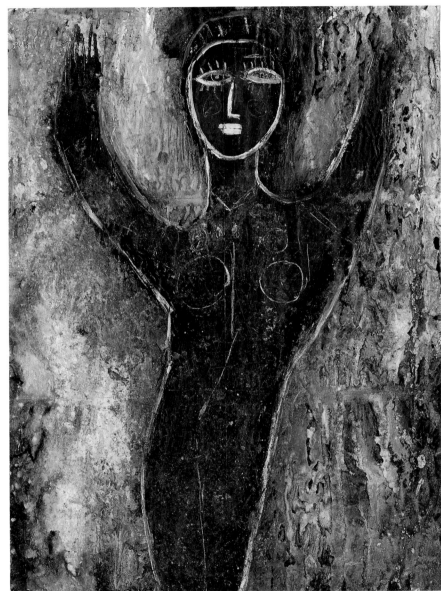

JAMALI'S SURFACE

By Donald Kuspit

Jamali is a mystic, and I think the surface of his paintings are emblematic of merger with the divine. That is, they represent the state of selflessness necessary to experience a sense of sacredness. One is in effect invited to lose oneself in the painting's surface, thus replicating the ecstatic state in which it was made.

This involves what Jamali calls his fresco tempera technique. Ground pigments are applied to a prepared canvas, which Jamali dances on. The pigments are then chemically bonded to the canvas. The result is a highly textured, intricate surface, simultaneously esoteric and erotic, intimate yet peculiarly forbidding and inscrutable. It is an essentially monotonic surface—a particularly dense all-over surface—but also sufficiently varied and complex to suggest an embryo-like process of self-differentiation, as well as, more generally, what Alfred North Whitehead called the creative flux. In other words, Jamali's surface is rich with implications and affinities.

Jamali's dancing is related to that of the Sufis, whom he first saw in the Rajasthan desert, where he spent five years. Carried to an extreme, dance can induce trance, particularly the swirling, repetitive dances of the Sufi mystics. Jamali's canvas dancing is no doubt carried out in a trance-like state, but the important point is that the residue of this state is alive on the canvas, in the form of the marks of his movement. The pigments are in effect the desert sand, and the marks are memory traces of the trance. Attuned to the painting's surface, one finds oneself dancing in the desert of one's mind—nimbly moving over a painterly surface.

From time immemorial the desert has been a place of vision: an abstract space of meditation and self-communion, far removed from the world. It has always been a kind of spiritual testing ground, a place where being has to prove itself, as it were: where the fundamental existential question whether to be or not to be is experienced with great urgency. Withdrawn into itself in the desert, with no practical concerns, the self searches for its raison d'être, more particularly, a "higher," general principle of being to justify its own existence. In other words, the desert experience has a double dimension: on the one hand, unworldliness, involving annihilation of the worldly self; on the other hand, otherworldliness, involving transcendence toward a different order of self (if it can still be called that) which brings with it awareness of a general principle of being. This "higher" self, with its "higher" awareness, can be felt in Jamali's surface, as both a diffuse idea and a specific presence—as its unbounded intention and indwelling immediacy.

If, as D. W. Winnicott has written, the mystic disengages from the world in order to engage his or her introjects, thus recovering a sense of vital self forgotten in daily commerce with the world, then one can say that these introjects are diffused throughout the vital self that is being re-experienced, recognized. One might say that Jamali's dancing invokes these "divine" introjects or inner powers, each one a distillate or quintessentialization of being: they spring from the canvas, as it were, which is not unlike the traditional sacred circle in which otherworldly spirits can be made to appear, with the proper method. Jamali's surface can also be regarded as a kind

187

of dream screen, or what André Breton called Leonardo's paranoid wall: but Jamali's introjects are benign, not vicious and sinister, like those Max Ernst and Salvador Dali saw in the textures of that wall.

Jamali's dancing is, then, magical in import, and the elusive visionary faces that often emerge on the surface of his paintings are sacred introjects: good internal objects that keep away the bad external objects of the world. These faces are generally schematic—radically simplified—as befits spiritual beings. Sometimes they surround an overtly angelic figure, as in *Butterfly of Kathmandu, 1991*. This work opens up another dimension of Jamali's paintings: their Tantrism. The Tantric practice of sexuality, like Sufi dancing, is a mystical practice. Jamali's butterfly is a female body in an ecstatic state, and thus spiritualized. Orgasmic nirvana is simultaneously spiritual transcendence, that is, transformation into a higher state of being, which the delicate butterfly represents. The butterfly's flight is not unlike the Sufi dance, in that it seems to be carried out in a trance. The visionary faces inhabit a higher, spiritual space; their presence indicates that the female butterfly has reached it—flown high indeed. Does the butterfly represent Jamali's own female side? Mysticism argues for the possibility of harmonious (however momentary) merger of seemingly irreconcilable beings, which necessarily involves reconciliation of all the disparate beings in the mystic's own psyche.

Many of Jamali's surfaces have leaves, twigs, even the remains of insects embedded in them. As he acknowledges, they were made outdoors, subject to the elements—rain and sun. Lizards sometimes crossed them. Clearly, a temporal process is involved, and the heavily encrusted result has the rich patina of an archeological find. Indeed, Jamali has spent much time at such archeological sites as Harappa, Mohenjadaro, and Taxila. One can regard his paintings as archeological sites of irreducible sensation, their surface as a field of archaic sensations exposed, as though for the first time, to the light of day and the mind. What one might call

the mysticism of time is involved: the peculiar way in which a timely sensation suddenly becomes a timeless feeling: the peculiar way in which a temporal signifier becomes, with the passage of time itself, a timeless mark, fraught with more meaning, however unspecifiable, than it had when it was a worldly index. Thus another merger of seemingly irreconcilable opposites: the marking of time and the duration that seems eternal because it is experienced as an indivisible event, like Jamali's surface.

But what perhaps is most involved in Jamali's surface is a mystical sense of being as such, that is, a sense of the unity of the inorganic and organic. At its most intense, his surface seems simultaneously both. This is not simply because the leaves and twigs are in effect petrified, or because the way Jamali has danced on the pigments seems to have brought them to life. Rather, it has to do with the overall substantiality—the peculiar materiality—of the paintings.

They often have the look of prehistoric cave paintings, indeed, of the stone walls on which such paintings were made. They often have the same crude, lush energy and imploded mass and monumentality of rough, raw material, which we experience as peculiarly elegant just because it is so primitive, and for which we feel a strange affinity, even empathy. Like the cave painters, Jamali's paintings show the same ambition to make contact with primordial being—to experience the sheer urgency of being. Thus they return us to perhaps the most archaic rationale for art, the rationale evident in the cave paintings, the rationale that has become explicit in modernist abstract painting: to make marks and gestures and images, not simply in order to show that we have the intelligence to do so, nor to record our presence for posterity (a dubious immortality, since anonymity comes with it), but rather out of wonder at being. Jamali makes art for the deepest of reasons: to try to grasp what it means to be by creating a new being. Or, less grandiosely, his paintings are a demonstration of being at its most esthetically fundamental: being as rhapsodic texture and delirious color.

Alphabetical List of Plates

Title, Plate Number

Age of Science, 40
Angel Pavon, 7
Ashes I, 17
Ashes II, 18

Backyard I, 49
Bhaiya-Bhaiya, 1
Bronze Age, 16
Bubble Room, 25
Butterfly of Kathmandu, 64

Cherokee Chief, 31

Dead Man Walking, 43
Divine Copulation
 with Death I, 56
Divine Copulation
 with Death II, 58

Earthman, 34
Event Horizon, 44

Falling Figure, 60
Figure and Mask, 6

Gate to Paradise, 66

Haiya-Haiya II, 45
Haiya-Haiya I, 46

Haiya-Haiya, 13
Herculanaeum, 2
Hero, 71
Homo Erectus, 55

Ishtar, 4

Journey of Hope II, 8
Journey of Hope, 9

King Nunn Nunn, 42
Kneeling Figure, 10

Manu, 68
Mask, 41
Meditation III, 12
Meditation, 32
Metaphysical Bicycle I, 26
Metaphysical Bicycle II, 62
Metaphysical Painting, 38
Morning Ragamala, 5
Mother, 57

New York Window I, 39
New York Window II, 36

Panic/Bliss, 47
Past Present Future, 14
Phoenix, 35
Play Triptych, 70
Profile, 28

Ragamala in Rajasthan I, 29
Ragamala in Rajasthan II, 30

Schrödinger's Cat, 15
Separation, 24
Shaman Triptych, 72
Stone Face, 19
Sufi-Gee I, 37
Sufi-Gee in the Evening, 61
Suicide of Lucretia I , 50
Suicide of Lucretia, 54
Susst, 33

Tantra Monkey, 69
The Druid, 11
The Poet I, 20
The Poet, 63
The Pointing Finger, 65
The Sacrifice, 53
The Seventh Circle of Hell, 59
The Swimmer, 3
Tin Man, 52
Torso I, 22
Torso II, 23
Torso III, 21
Torso IV, 51
Torso V, 48

White Surface, 67

Zen Mouse, 27

Designed by Bruce Campbell, Mystic, Connecticut

Typeset in Centaur and Bembo by Anandaroop Roy, Stonington, Connecticut

Photography by Kent Barker, Jeff League, and Jim Leatherman,

Winter Park, Florida

Printed and bound in an edition of 5000 copies

by Amilcare Pizzi S.p.A., Milan